nationalgeographicmoments**WEDDINGS**nationalgeographicmoments**WEDDINGS**nationalgeographicmoments**WEDDINGS**nationalgeographicmoments**WEDDINGS**nationalgeographicmoments**WEDDINGS**nationalgeographicmoments**WEDDINGS**nationalgeographicmoments**WEDDINGS**nationalgeographicmoments**WEDDINGS**nationalgeographicmoments**WEDDINGS**nationalgeographicmoments**WEDDINGS**nationalgeographicmoments**WEDDINGS**nationalgeographicmoments**WEDDINGS**nationalgeographicmoments**WEDDINGS**nationalgeographicmoments**WEDDINGS**nationalgeographicmoments**WEDDINGS**nationalgeographicmoments**WEDDINGS**nationalgeographicmoments**WEDDINGS**nationalgeographicmoments**WEDDINGS**nationalgeographicmoments

eddingsweddingsWEDDINGSweddingsweddings

national geographic *moments*

WEDDIN

by Leah Bendavid-Val

Weddings

"To speak frankly, I am not in favor of long engagements. They give people an opportunity of finding out each other's characters before marriage. Which I think is never advisable." So says Oscar Wilde in *The Importance of Being Earnest*. Wilde obviously presumed that familiarity dampens ardor. Couples fall in love, then fall out of love; it's a central theme in music, literature, movies, and other arts. ❖ People have fallen in love since hearts began to beat, but in Europe they didn't even think of marrying for it until the ninth or tenth century. The lower classes married for love before the upper classes did. Rich and powerful people could and did use marriage to increase their possessions and reinforce their social and political standing. ❖ The story was no different in Asia, Africa, and the Americas: Marriage was a union between two families. A profitable match could link groups economically and politically over a large geographical area. It was far too serious to be left to young couples. ❖ Change came in fits and starts. Romeo and Juliet, going against their families and tradition, and giving all for love, were shown by Shakespeare to be bold and pure. Their

love, according to Shakespeare, improved the world they left behind. Earlier civilizations would have disputed this—the young couple's behavior would have seemed immature and selfish, and certainly destructive to the social order. ❖ Photographers started taking pictures of brides and grooms when photography was new. Couples were locked rigidly in place for photographic sittings because cameras were slow, and film insensitive. Nowadays families hire skilled photographers toting sophisticated equipment and have meetings ahead of time to plan the wedding coverage. To supplement the professional work, disposable cameras are placed on tables so guests may contribute to the wedding album. Still, it is difficult to imagine a tougher job than being the photographer for a (one hopes) once-in-a-lifetime wedding. ❖ In November 1963 NATIONAL GEOGRAPHIC magazine published "Wedding of Two Worlds." The story was about a marriage that took place in Sikkim, a Himalayan kingdom tucked between India, Nepal, and Tibet. Prince Palden Thondup Namgyal was marrying debutante Hope Cooke from Manhattan, just graduated from Sarah Lawrence College in Bronxville, New York. The ceremony had been long awaited—delayed

a year because astrologers determined that the arrangement of planets was inauspicious for 1962. When the day finally came, the marriage rites of Sikkimese Buddhists were carried out meticulously. Writer-photographer Lee Battaglia documented the event wedding-album style, from beginning to end. In spite of the solemn ritual, the romance that began when the couple met in Darjeeling, India, in 1959, when Hope Cooke was there on vacation, shone through. And looking back at that magazine issue now it is clear that the author-photographer had himself fallen in love with the story. ❧ Albums testify to the fact that of all our rituals, weddings are the most celebrated and remembered. We know about the wedding of our parents from pictures and reminiscences. We remember not only our own wedding but the weddings of friends and relatives, and if we're unmarried we have thought about the wedding we want, or don't want. ❧ The bride is the center of every wedding pageant, rural and urban, from the most humble ceremony to the most opulent royal extravaganza. Bridal fashion, as you can see in these pages, has varied enormously. But at least two symbols— representing purity and fertility— are always present. ❧ The veil, be

it lace or silk, symbolizes purity. It cannot help but suggest mystery as well. In some bygone cultures grooms didn't lay eyes upon their brides until the veil was lifted at the wedding ceremony. Both partners hoped they could love each other eventually, if not at first sight. ❧ In Western weddings white dresses and pearls also express purity. The tradition of a white wedding dress began in 1840 when England's Queen Victoria wore white, instead of the customary silver, to marry her cousin Prince Albert. But white is not the bridal color in every culture. Brides wear red in China, the Caucasus, and Armenia. In Switzerland both bride and groom commonly wear black. ❧ Flowers, worn or carried, symbolize fertility. Actually almost any plant that grows might serve this purpose. Agrarian brides wore garlands of leaves or herbs representing Earth's abundance and the couple's hope for a large family. ❧ The bride must, above all, look beautiful on her wedding day. And beauty looks different in different places, to different people, and from era to era. Jewels may be extravagant or delicate; hands, nails, feet, or face may be painted painstakingly or not at all; garlands, veils, or crowns may conceal or reveal; dresses may be short or long, slinky or ruffled

and draped. ∾ In GEOGRAPHIC magazine stories about world cultures, weddings often appear in the mix of pictures; a cornucopia of rituals, memories, and hopes are held in that one event. But an entire story about one wedding is rare in the magazine; there have been only three since the November 1963 story about Hope Cooke and her prince. ∾ For "Brides of the Sahara," published in February 1998, photographers Carol Beckwith and Angela Fisher recorded the elaborate, week-long ceremonies surrounding the marriage of a 15-year-old girl to her 25-year-old cousin. They delved deeply into the Tuaregs' seminomadic way of life to tell the story. The week's events began with guests arriving on camelback. Tuareg women built a nuptial tent of palm-frond mats and blankets for the couple; they dismantled and rebuilt it larger to mark each day of the ceremony. Inside the tent the bride lay wrapped in white, next to her closest friend. During the week of ceremonies she was allowed to speak only to this friend, her mother, her husband, and the artisan who attended her. The artisan braided her hair elaborately and made sure her dress was perfect. The turbaned groom, too, had female artisans. They covered his hands and feet with henna and wrapped

them in plastic. The reddish brown result would remain on his skin for several months. This wedding even provided opportunities for unmarried women to look for marriage prospects. ❧ Beckwith and Fisher went on to document marriages across the length and breadth of Africa. They traveled for a decade, by camel, mule train, and four-wheel drive, acutely aware that centuries-old wedding ceremonies are disappearing, giving way to the power of modern culture. They photographed their way across the continent fired with the mission to preserve intricately layered wedding traditions on film. In their story, gold and silk, beads and paint adorn anticipant brides and grooms who remember the past as they dream of the future. ❧

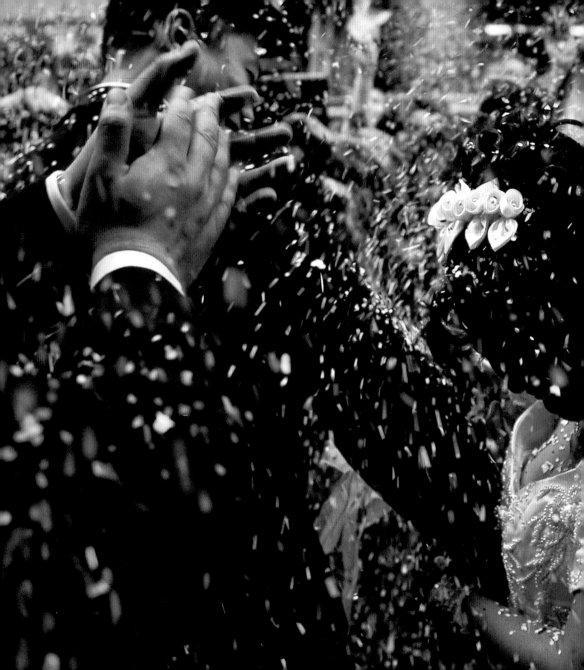

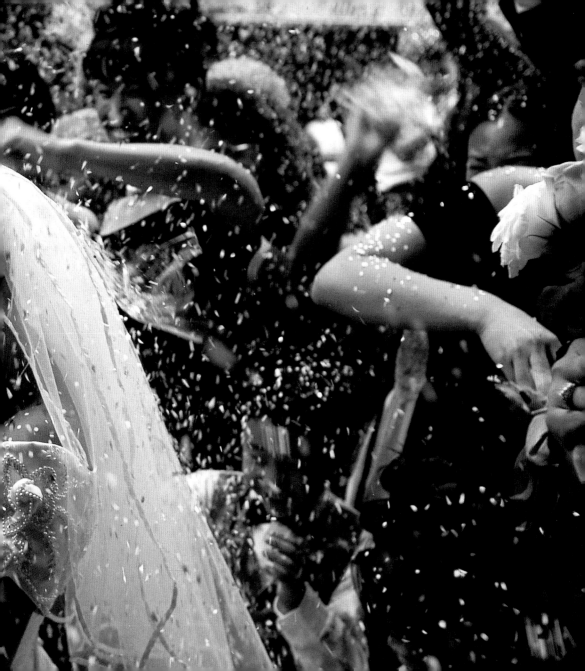

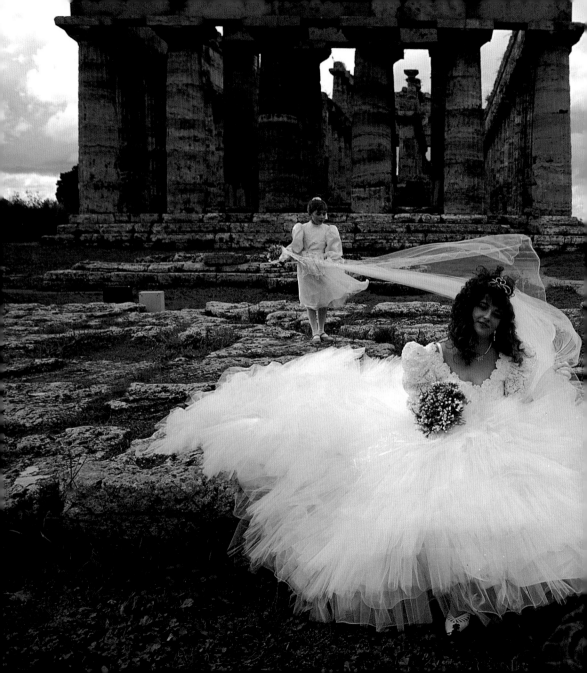

PAESTUM, GREECE
1994
SISSE BRIMBERG

preceding pages
NEW YORK, NEW YORK
1998
CHIEN-CHI CHANG

following pages
WEST POINT, NEW YORK
1952
B. ANTHONY STEWART

EUROPE
2001
TOMASZ TOMASZEWSKI

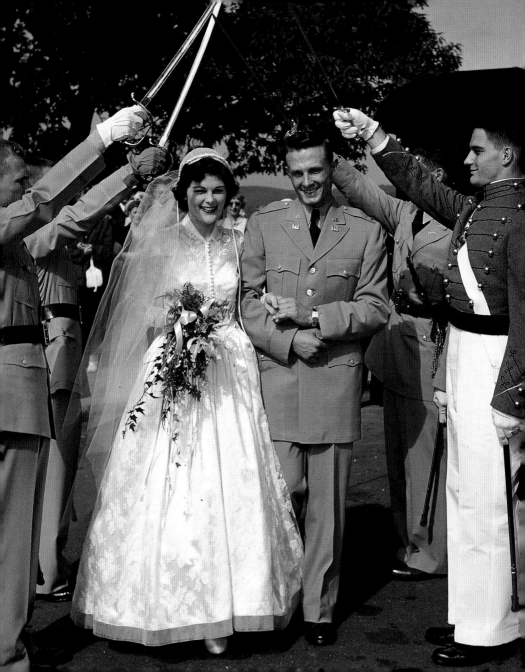

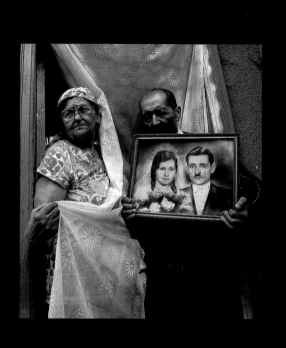

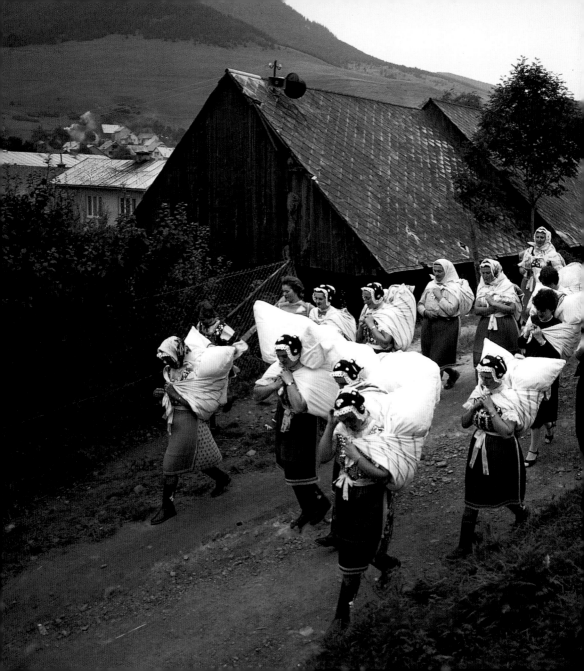

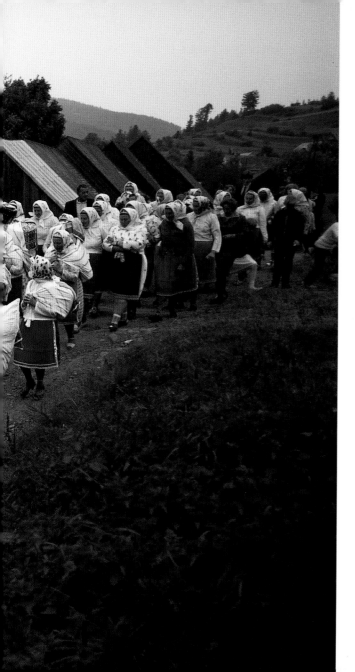

LENDAK, SLOVAKIA
1987
JOHN EASTCOTT AND
YVA MOMATIUK

following pages
TUNISIA
1943
RENÉE GESMAR

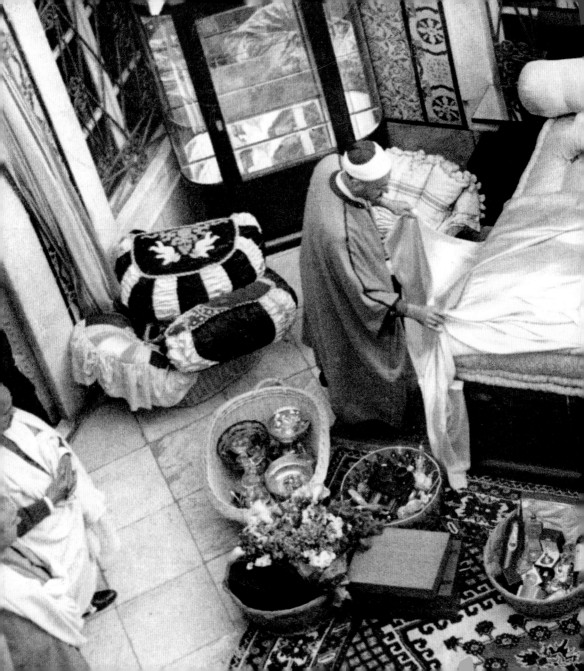

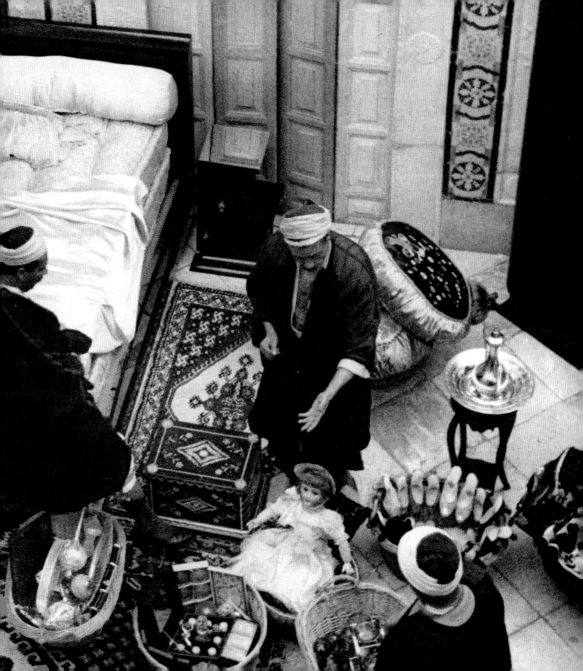

It could be fairly said that weddin

preparations begin when we are children. Manikins in shop windows and pictures in magazines show youngsters what brides look like. A bride's dream gown will be white and flowing, but only if her dreams are based on a tradition that started with England's Queen Victoria in 1840. Fortunately, cameras have also captured wedding garb unfamiliar to Western eyes—elaborate headdresses, body paint, and exquisite silk and beaded outfits.

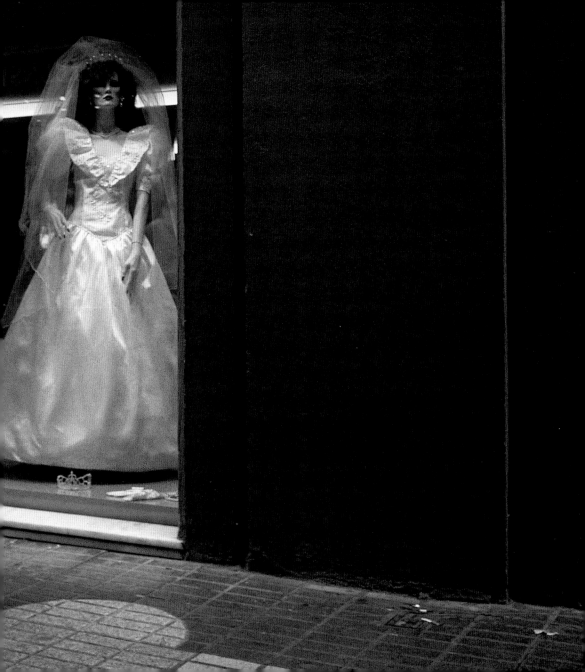

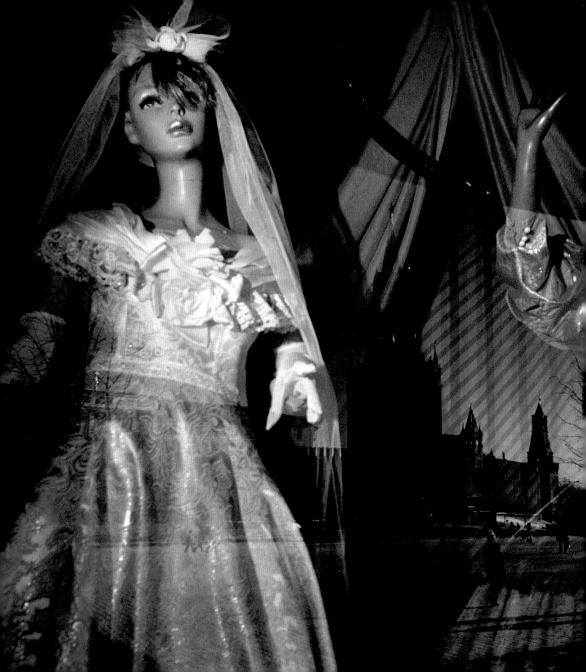

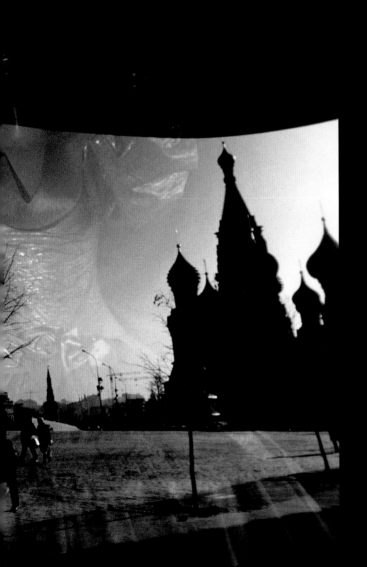

MOSCOW, RUSSIA
1996
GERD LUDWIG

preceding pages
SEVILLE, SPAIN
1992
DAVID ALAN HARVEY

following pages
ECUADOR
2001
PABLO CORRAL-VEGA

MONTANA
1996
WILLIAM ALBERT
ALLARD

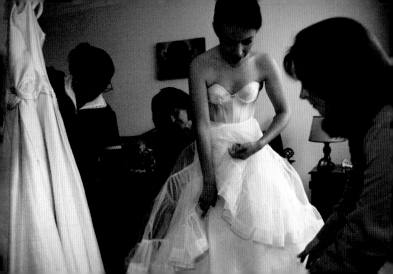

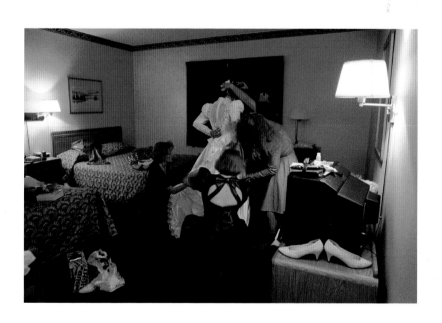

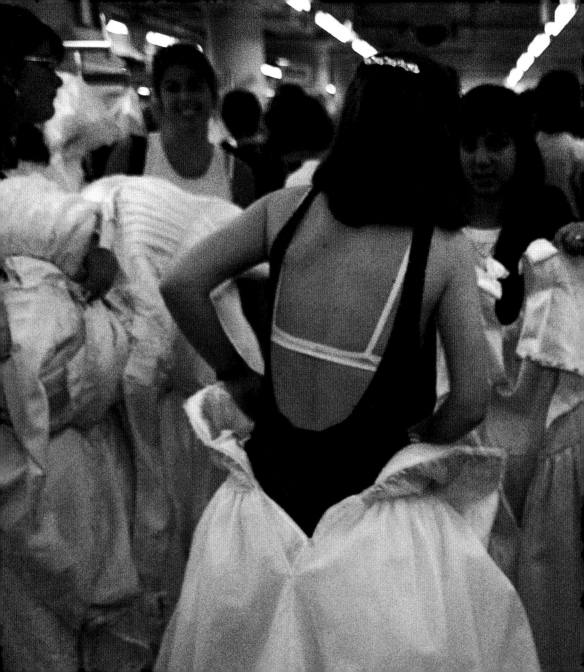

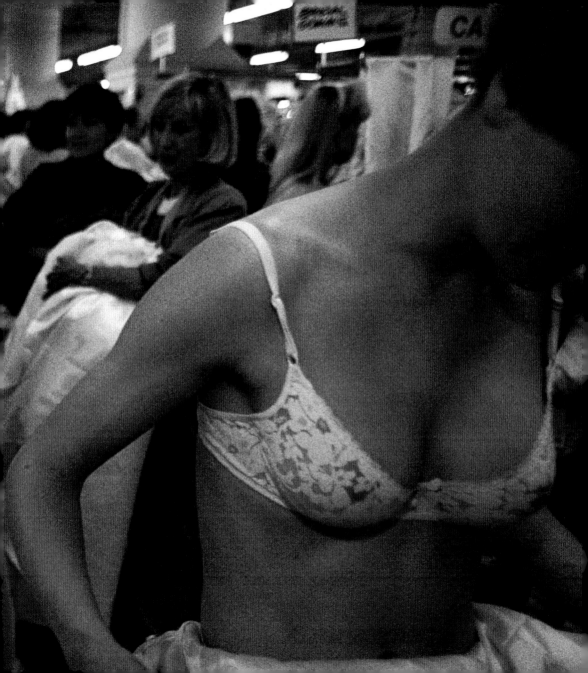

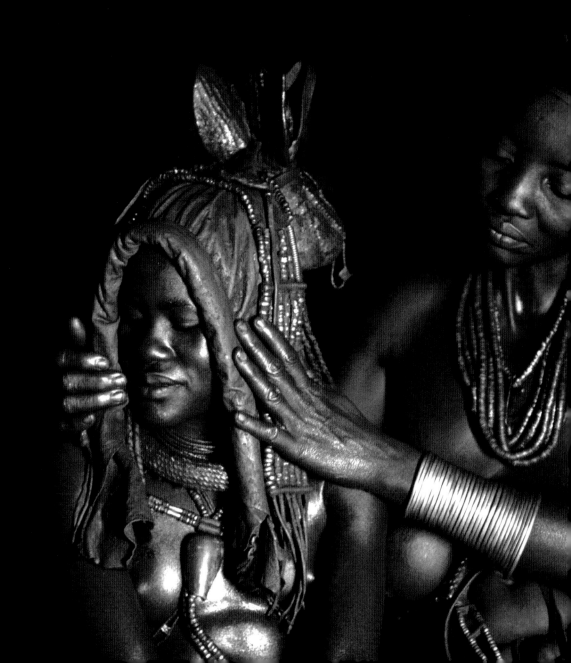

NAMIBIA
1999
CAROL BECKWITH AND
ANGELA FISHER

preceding pages
BOSTON, MASSACHUSETTS
1993
JOEL SARTORE

JAPAN
DATE UNKNOWN
PHOTOGRAPHER
UNKNOWN

following pages
**JAKARTA, JAVA ISLAND,
INDONESIA**
1987
MICHAEL YAMASHITA

MEXICO CITY, MEXICO
1984
STEPHANIE MAZE

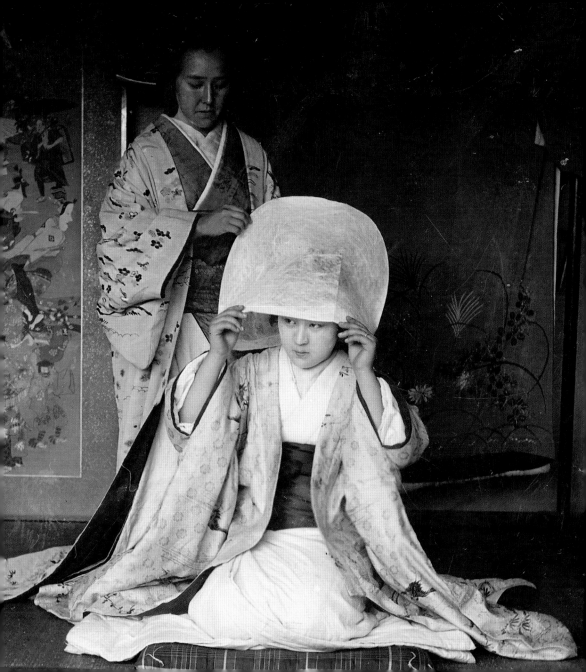

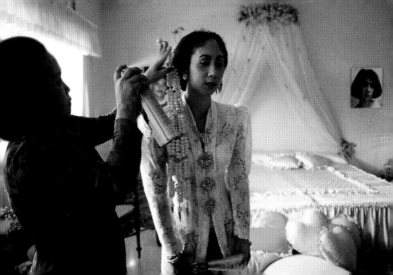

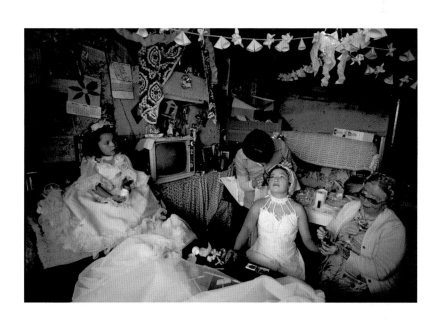

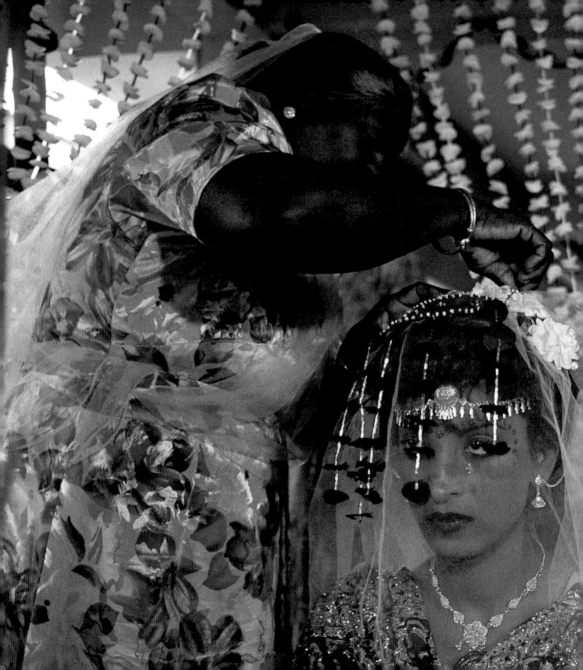

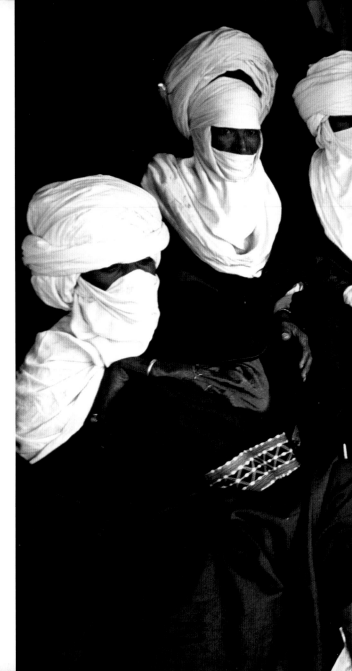

NIGER
1998
CAROL BECKWITH AND
ANGELA FISHER

preceding pages
CHARLIEVILLE, TRINIDAD
1994
DAVID ALAN HARVEY

following pages
**MOOREA,
FRENCH POLYNESIA**
1997
JODI COBB

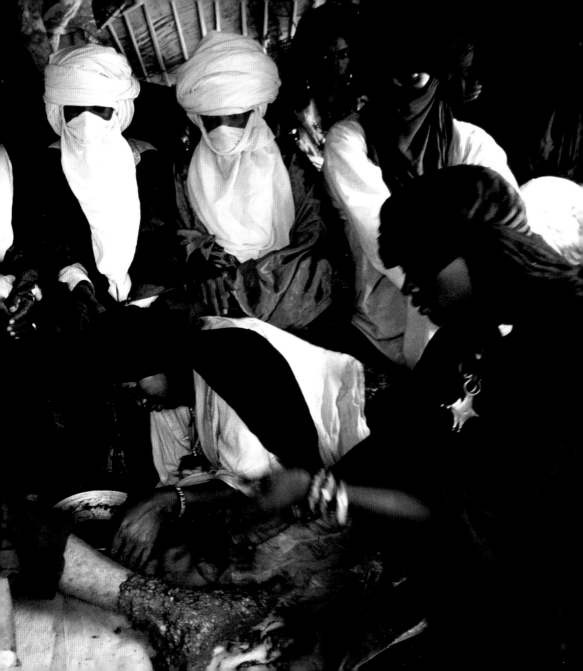

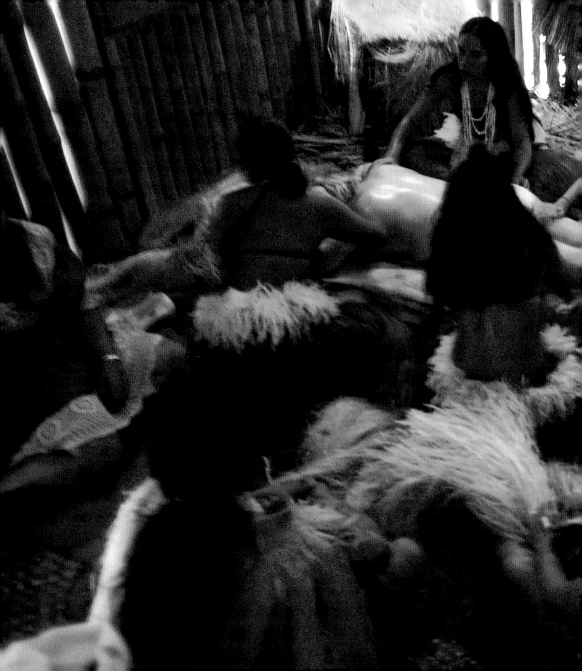

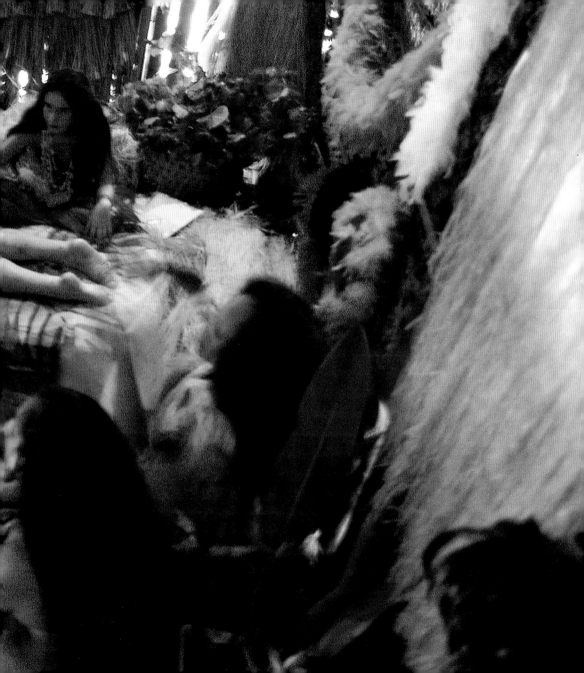

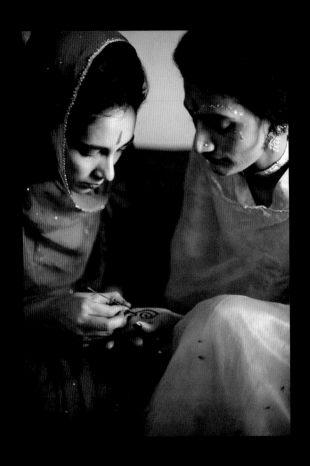

INDIA
1965
MARILYN SILVERSTONE

following pages
OMAN
1995
JAMES L. STANFIELD

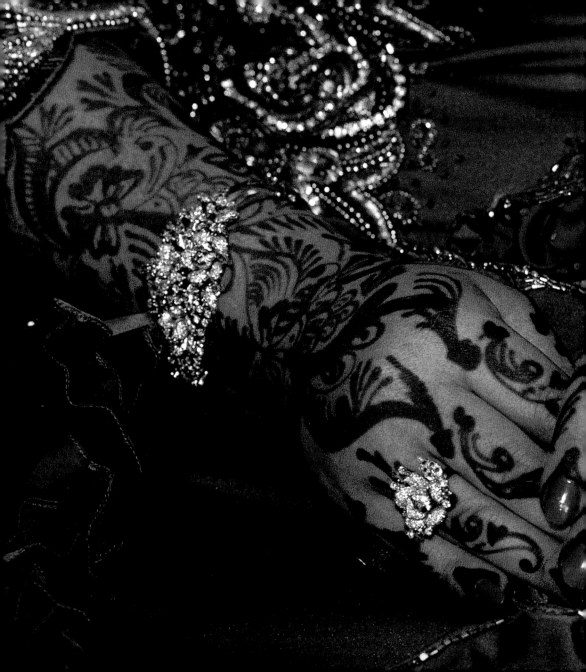

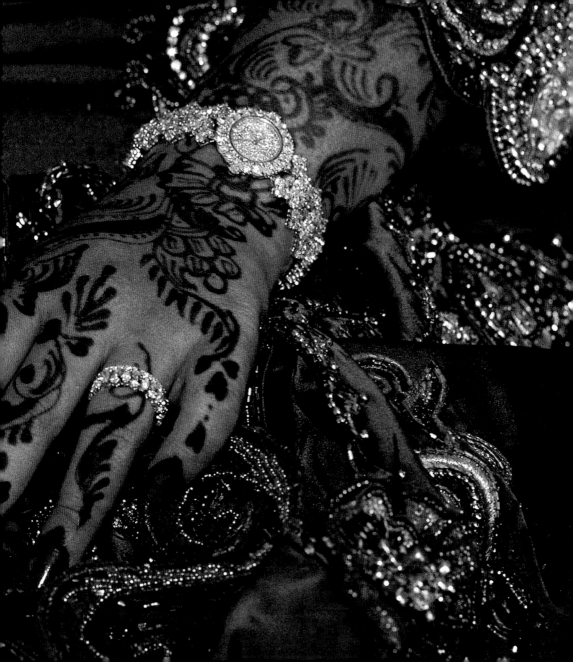

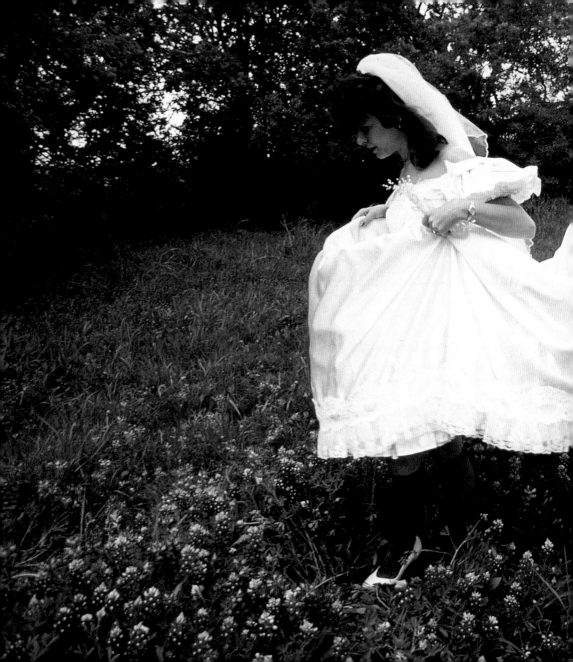

NEAR BRENHAM, TEXAS
1986
CHARLES O'REAR

Dressed for the biggest momen

of their lives so far, young brides pose for portraits. Finished pictures show shy young women, extravagantly but modestly dressed. Even the most humble family goes all out. Photographers from Edward Curtis, who spent 30 years taking over 40,000 pictures of American Indians, to Carol Beckwith and Angela Fisher, photographing for 10 years in the Sahara, have trained their cameras on bridal beauty.

NORWAY
1935
PER BRAATEN

following pages
NEW DELHI, INDIA
1942
MAYNARD OWEN
WILLIAMS

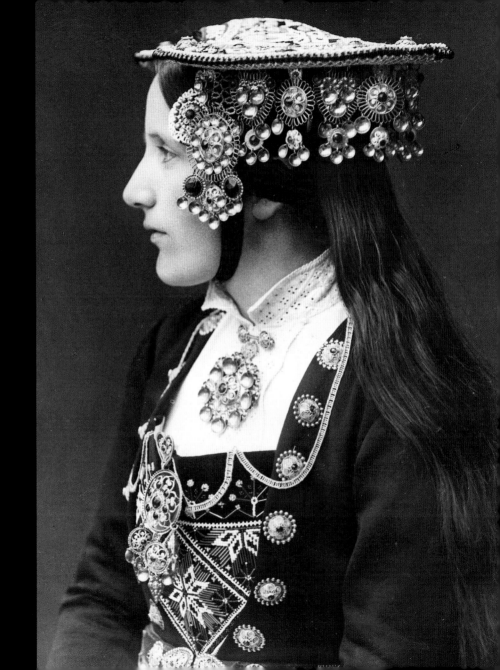

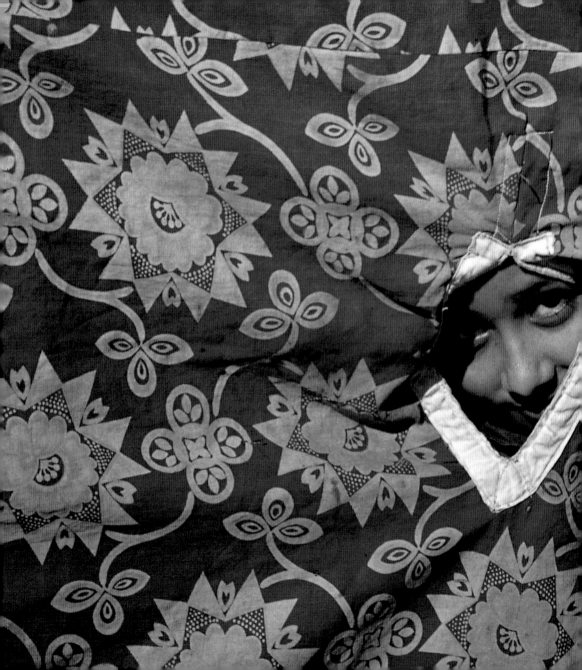

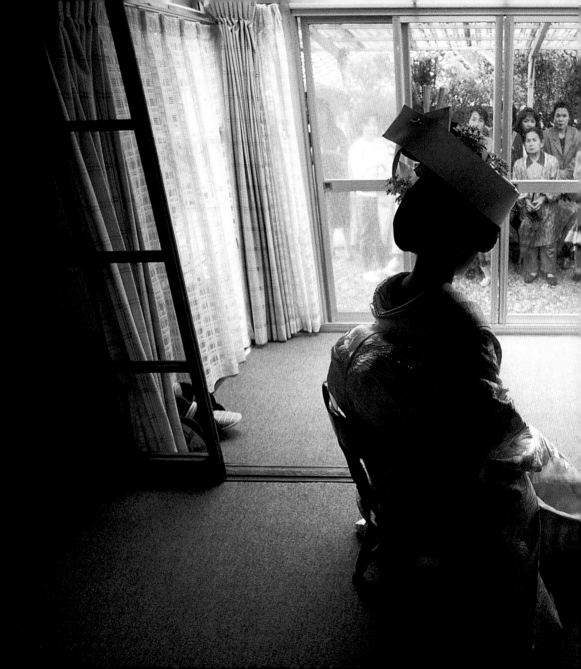

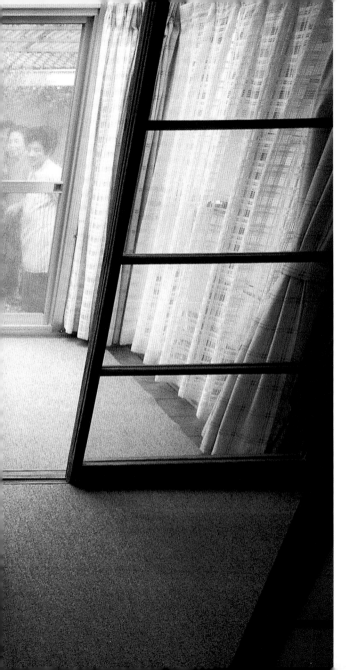

JAPAN
1990
KAREN KASMAUSKI

following pages
WASHINGTON
DATE UNKNOWN
EDWARD S. CURTIS

HUNGARY
1914
A. W. CUTLER

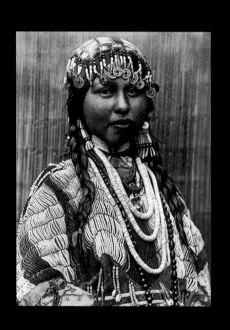

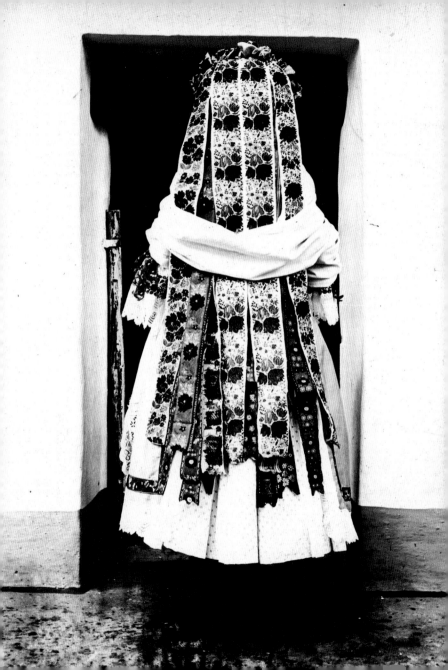

ISRAEL
1985
JAMES L. STANFIELD

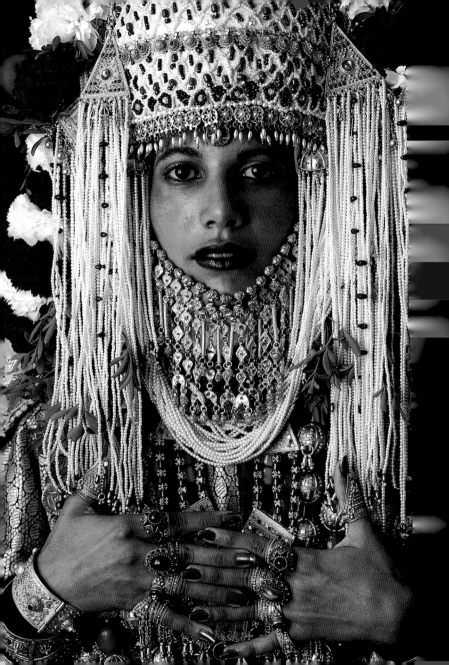

The road to the matrimon

walked over rough terrain or driven in a classy limo.

t whatever the means of locomotion and whoever the couple,

otions are high. The solemn ceremony is deepened with rituals.

he past, marriages were arranged to promote alliances between fami-

, and sometimes couples didn't know each other before their weddings.

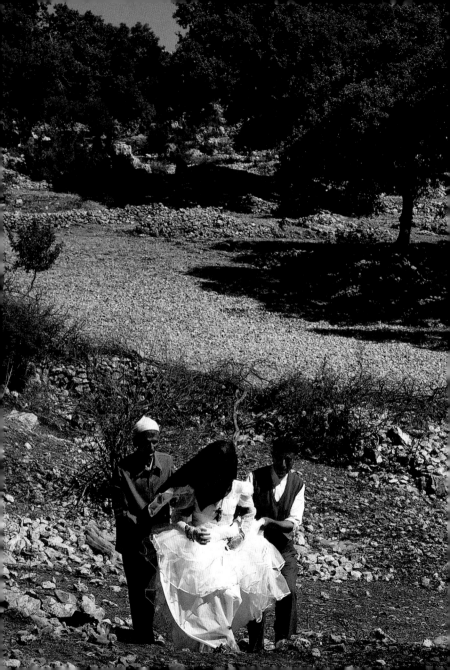

TURKEY
1994
REZA

following pages
INDIA
1965
MARILYN SILVERSTONE

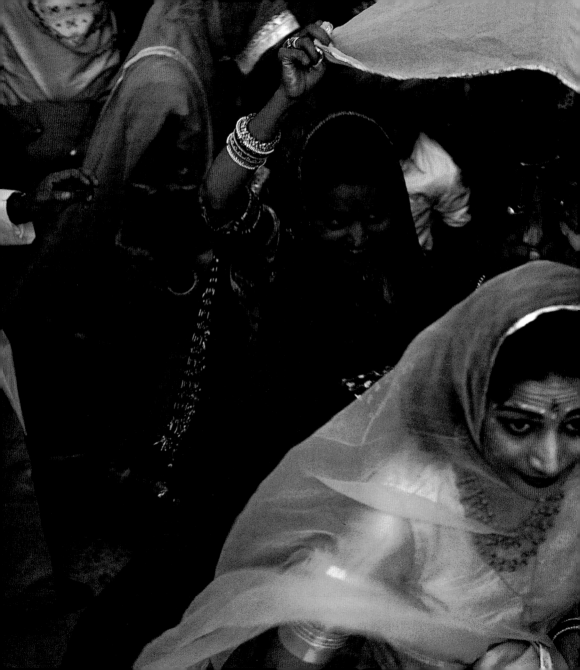

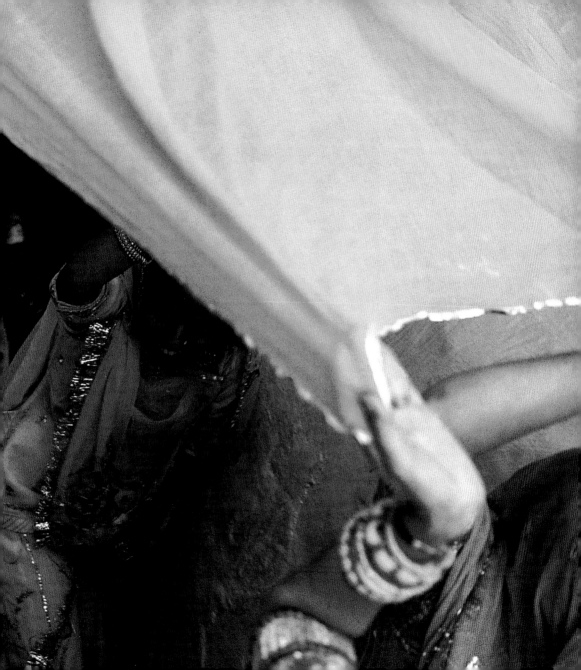

BADEN, GERMANY
1927
KARL OBERT

following pages
FEZ, MOROCCO
1986
BRUNO BARBEY

MANILA,
THE PHILIPPINES
1990
SISSE BRIMBERG

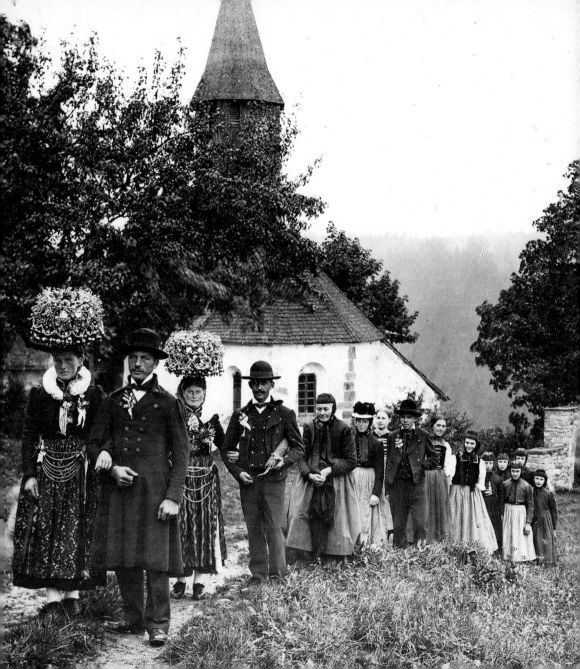

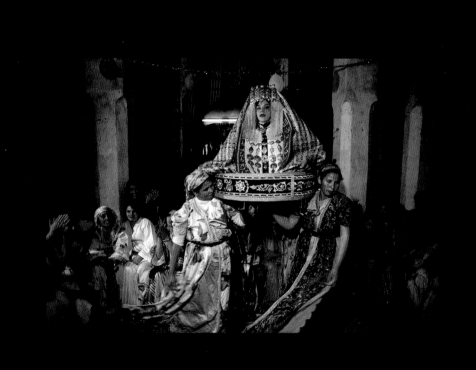

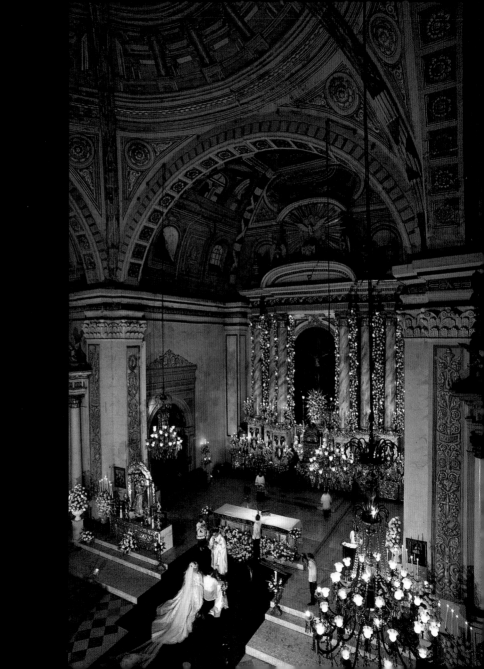

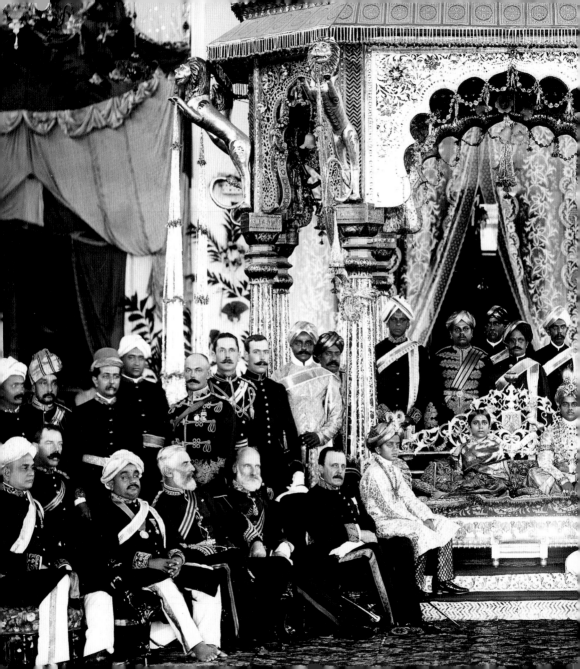

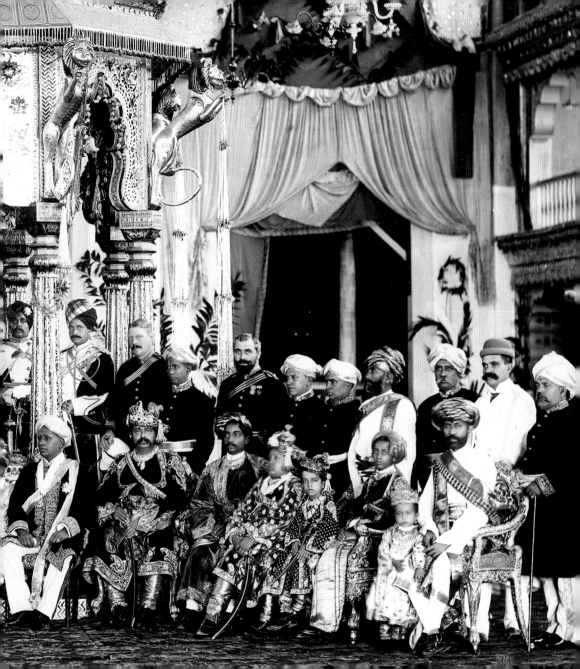

KUYBYSHEV, RUSSIA
1992
JAMES P. BLAIR

preceding pages
INDIA
1917
BARTON & SON

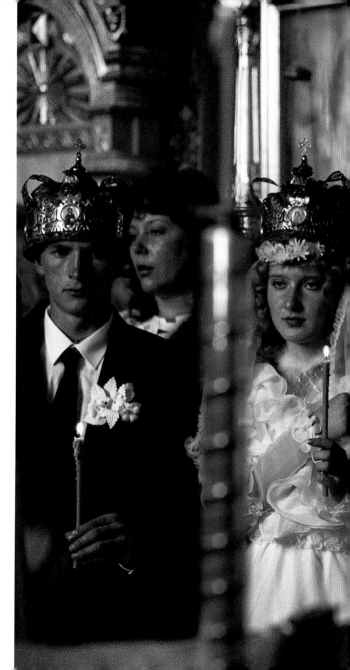

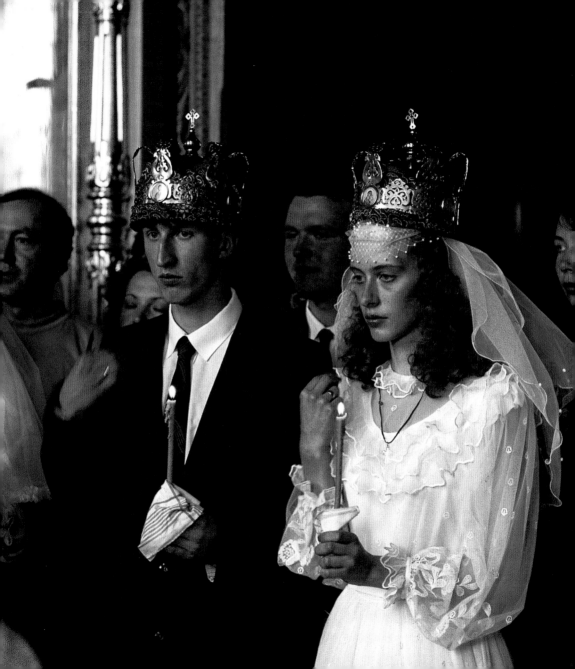

LENDAK, SLOVAKIA
1987
JOHN EASTCOTT AND
YVA MOMATIUK

following pages
SUTKA, MACEDONIA
1996
SARAH LEEN

JERUSALEM, ISRAEL
1995
ANNIE GRIFFITHS BELT

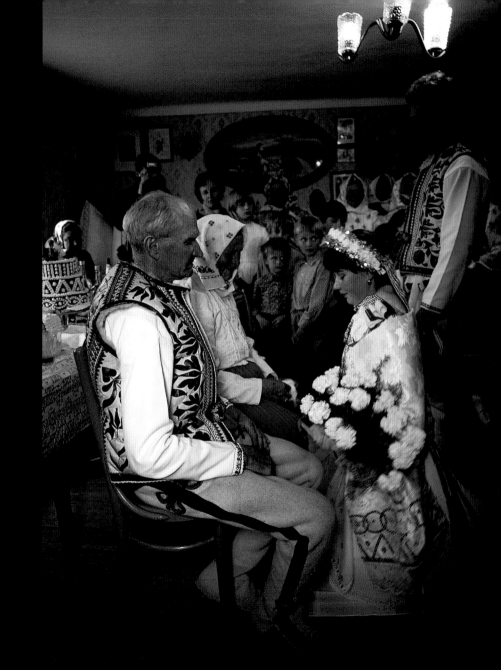

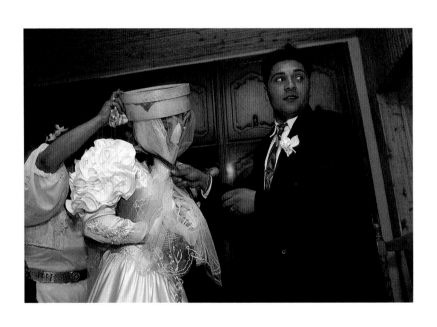

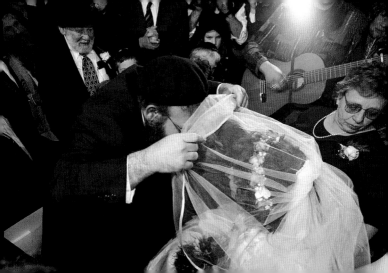

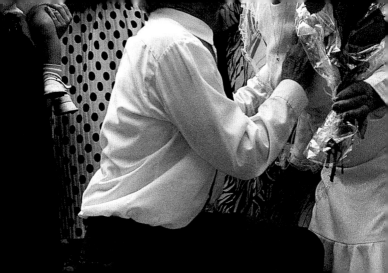

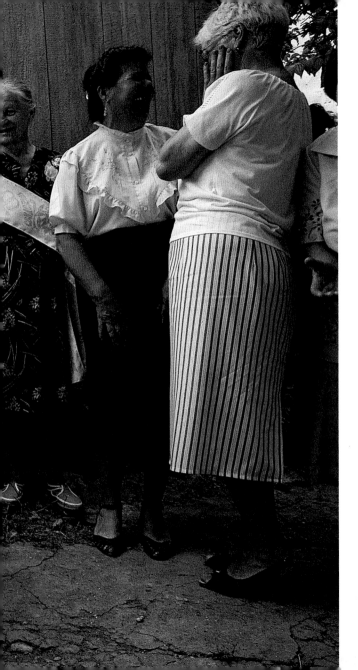

SEVASTOPOL, CRIMEA
1994
ED KASHI

following pages
SICILY, ITALY
1994
WILLIAM ALBERT ALLARD

LONDON, ENGLAND
2000
JODI COBB

HYDERBAD, INDIA
1994
ROBB KENDRICK

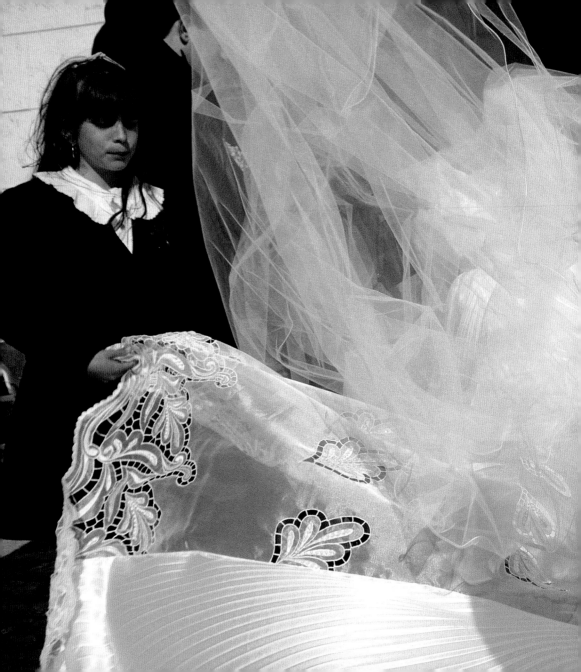

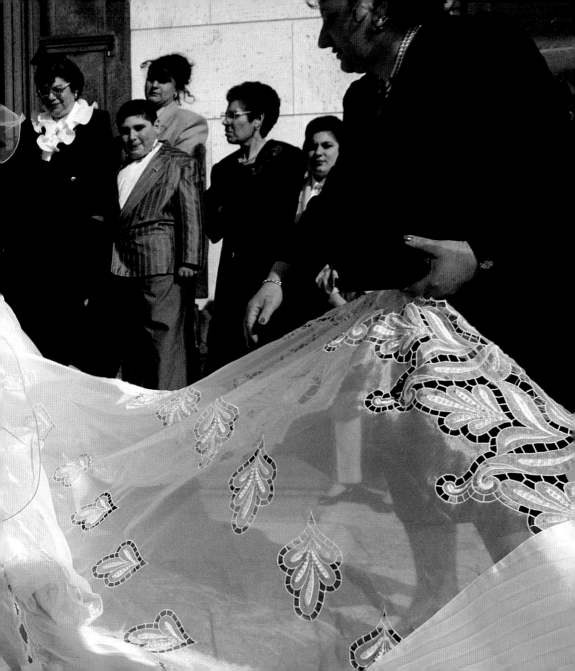

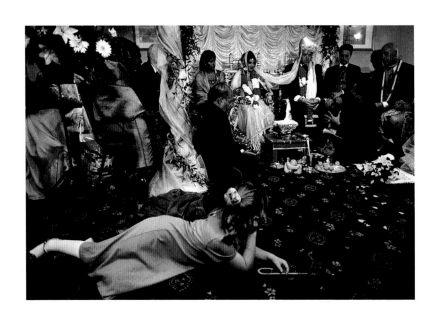

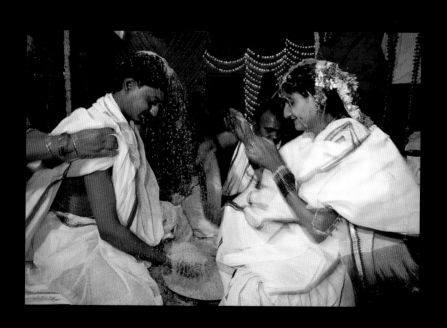

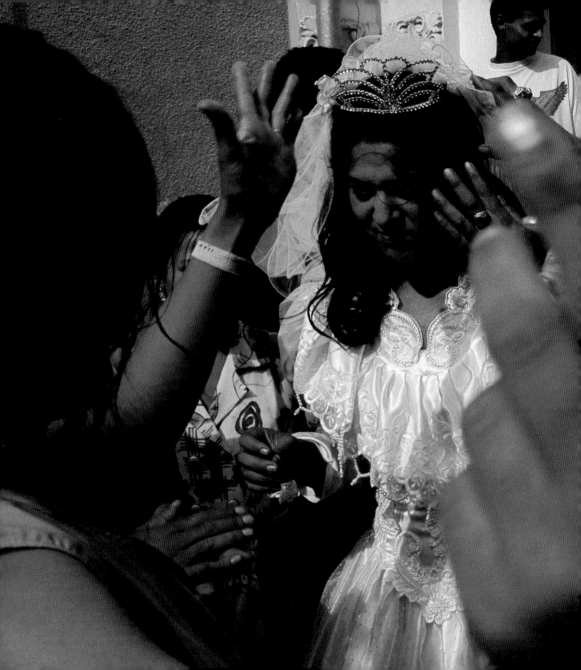

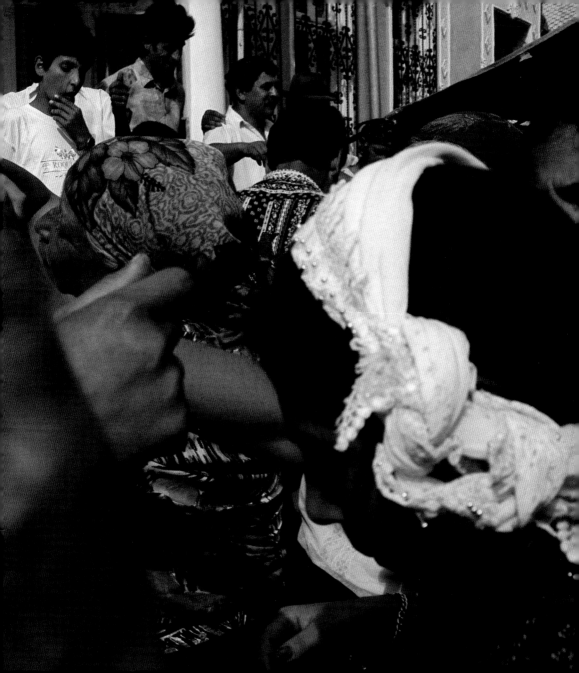

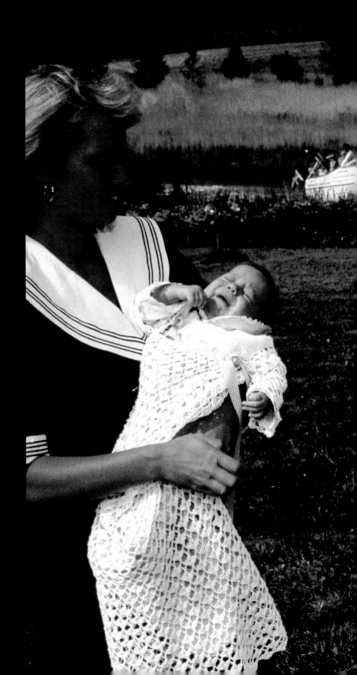

INGARO, SWEDEN
1992
TOMASZ TOMASZEWSKI

preceding pages
ROMANIA
2001
TOMASZ TOMASZEWSKI

following pages
SAUDI ARABIA
1987
JODI COBB

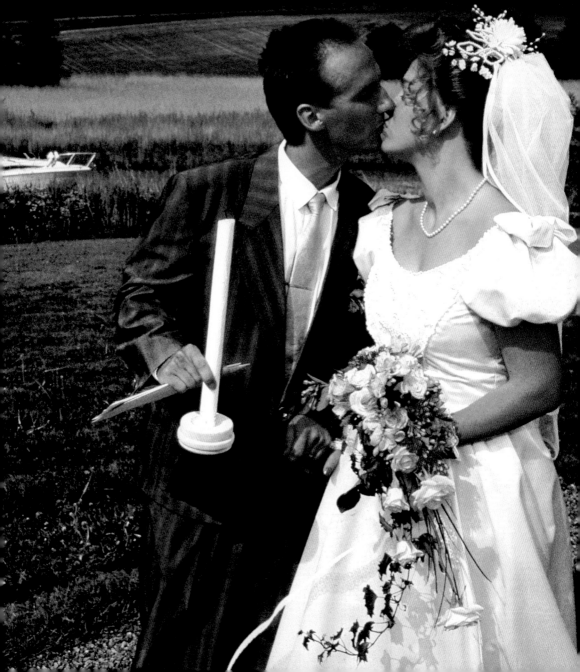

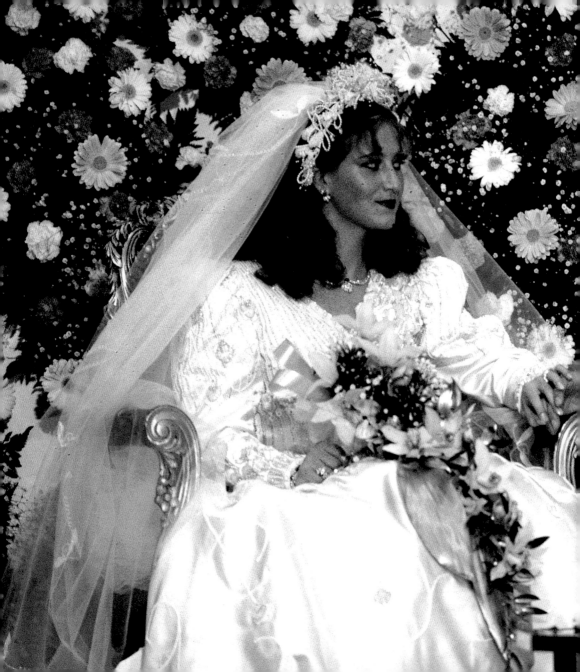

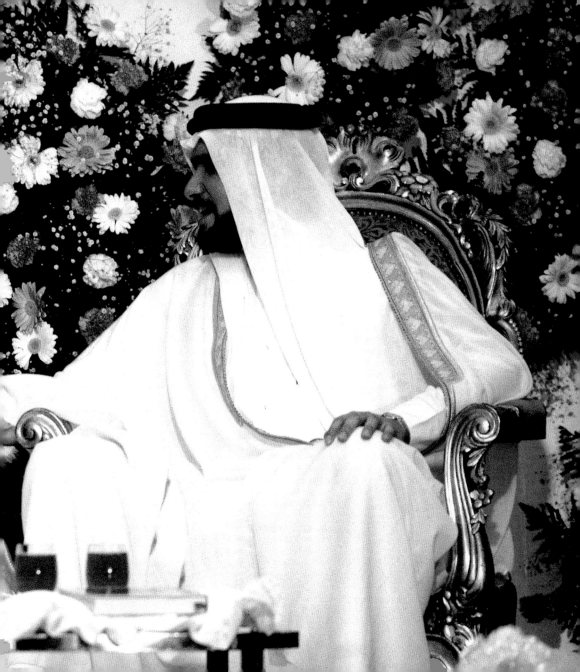

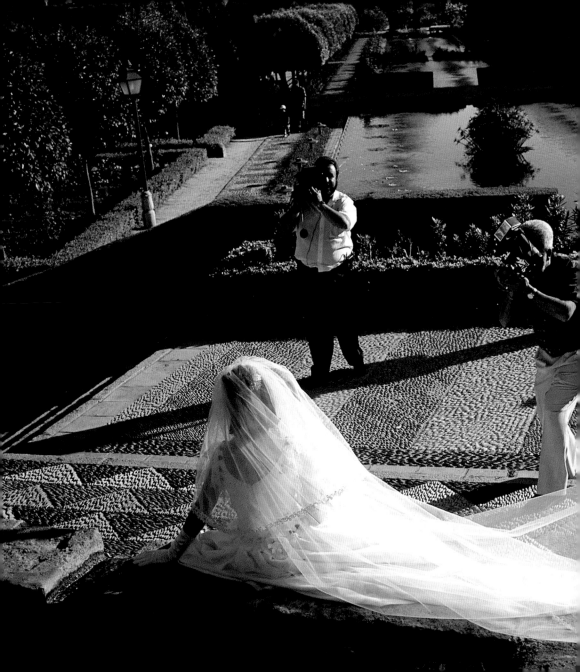

CORDOBA, SPAIN
1999
STUART FRANKLIN

Tears of tension are photographed

from Rajasthan, India, to Pineville, West Virginia, to Fukui Prefecture in Japan. Photographers also capture more contemplative moments—a bride in quiet conversation with her grandmother or her groom, or having a drink in a diner with friends. The photographs are evidence of the obvious—that vastly different couples have similar emotions. The party that follows the pledging of vows may be raucous or quiet, but always features splendid food.

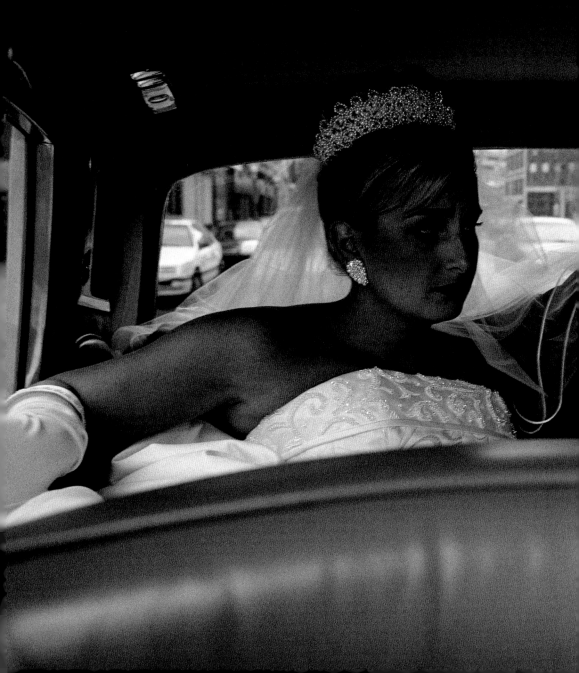

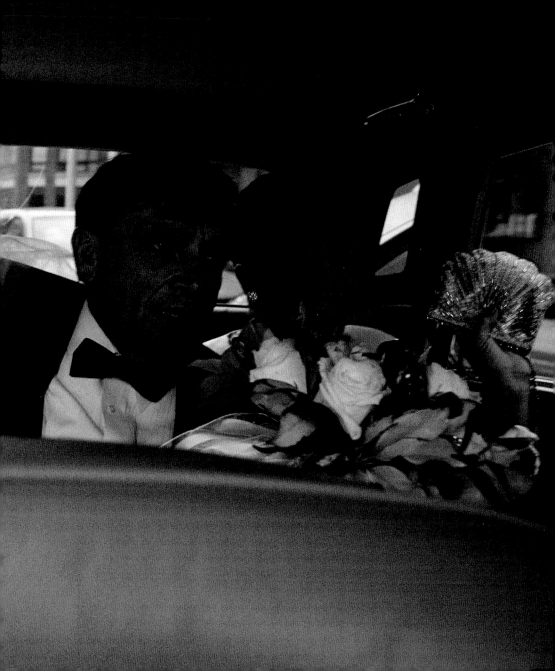

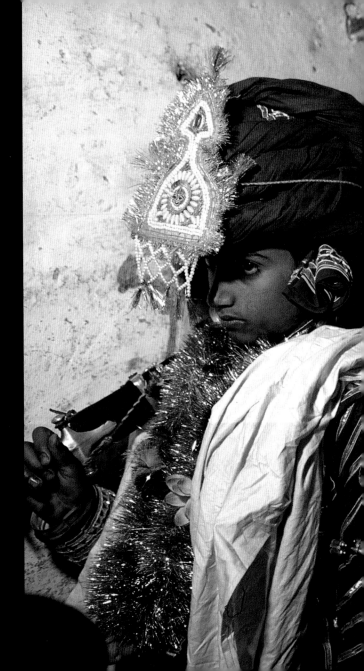

RAJASTHAN, INDIA
993
DILIP MEHTA

preceding pages
BOSTON,
MASSACHUSETTS
2000
WILLIAM ALBERT ALLARD

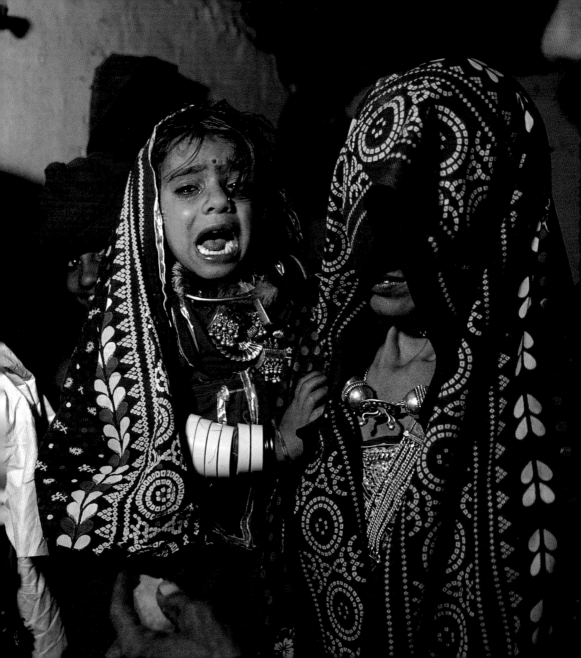

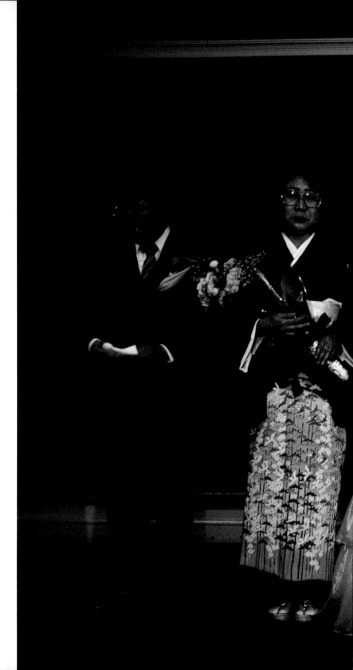

KYOTO, JAPAN
1990
KAREN KASMAUSKI

following pages
**CINEMA CITY,
OUTSIDE ROME, ITALY**
1961
JAMES P. BLAIR

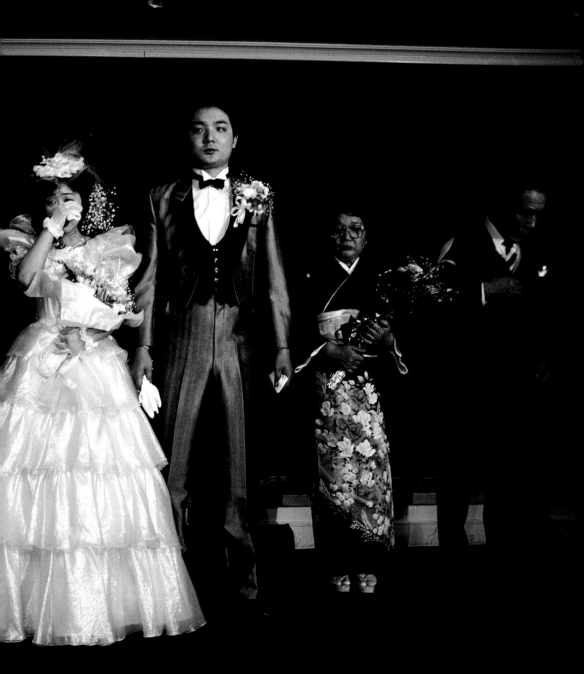

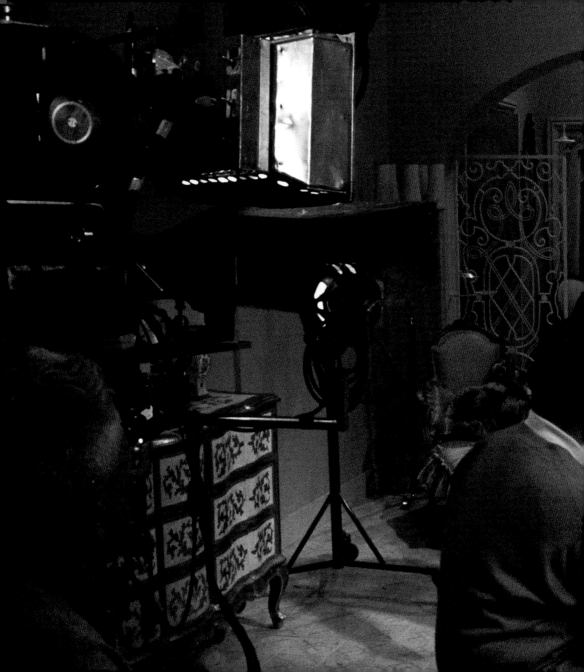

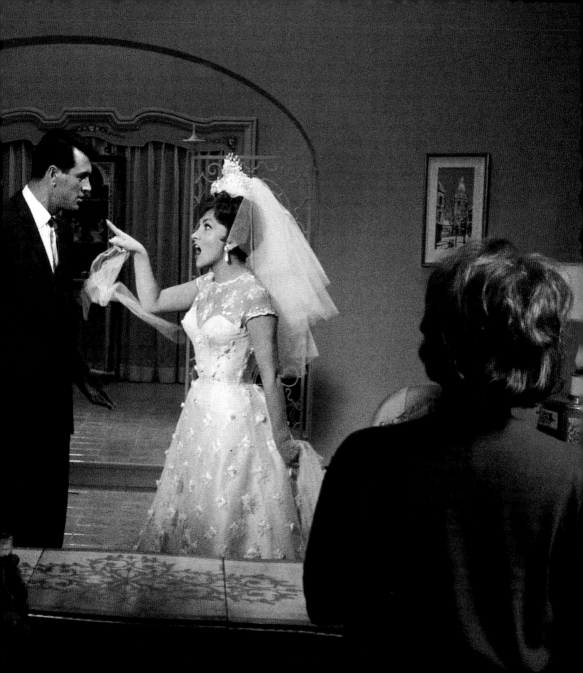

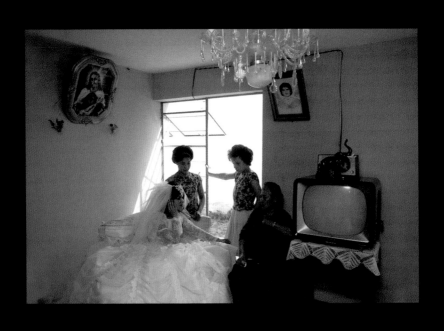

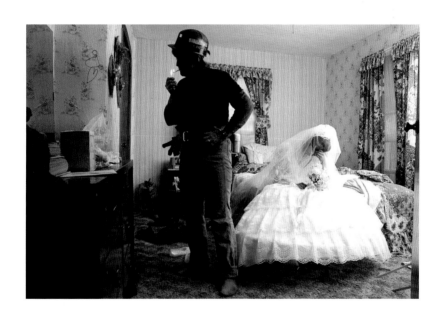

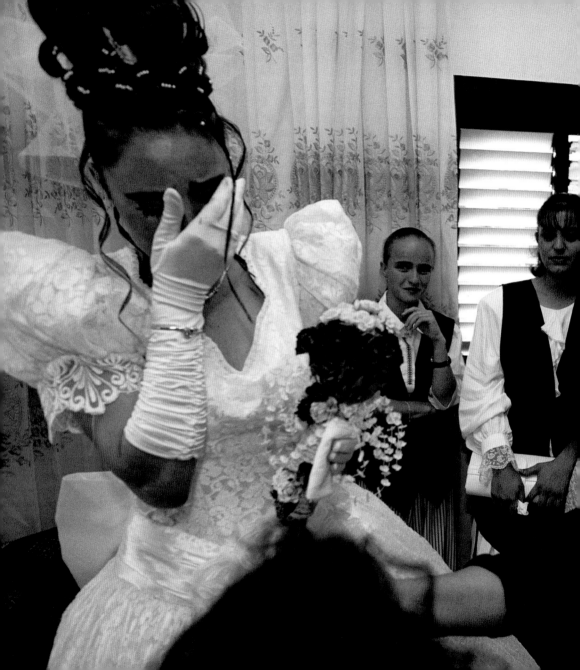

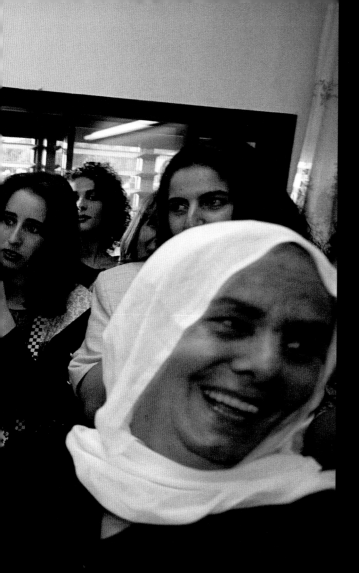

GALILEE, ISRAEL,
PALESTINE
1994
ANNIE GRIFFITHS BELT

preceding pages
LIMA, PERU
1964
BATES LITTLEHALES

PINEVILLE, WEST VIRGINIA
1986
JAMES L. STANFIELD

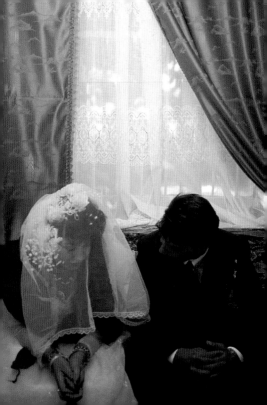

CATAK, KURDISTAN,
TURKEY
1991
ED KASHI

KOWLOON, HONG KONG
1990
JODI COBB

following pages
ROMANIA
1983
JAMES L. STANFIELD

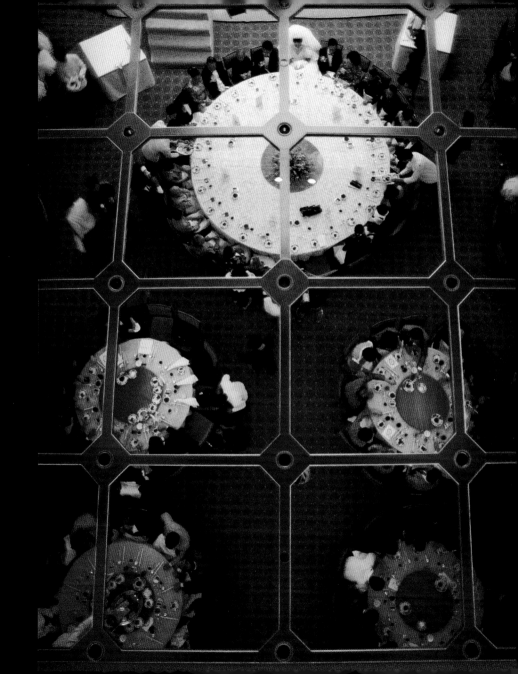

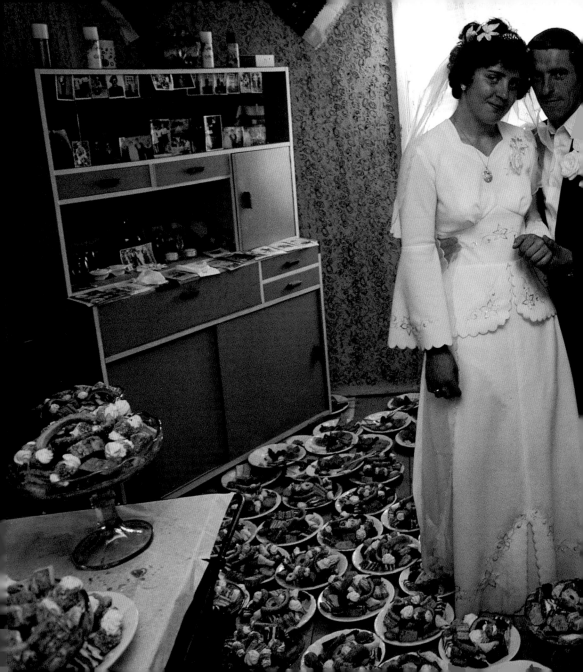

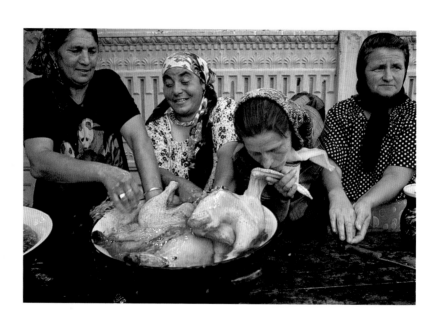

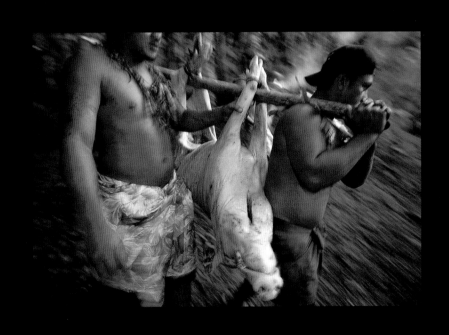

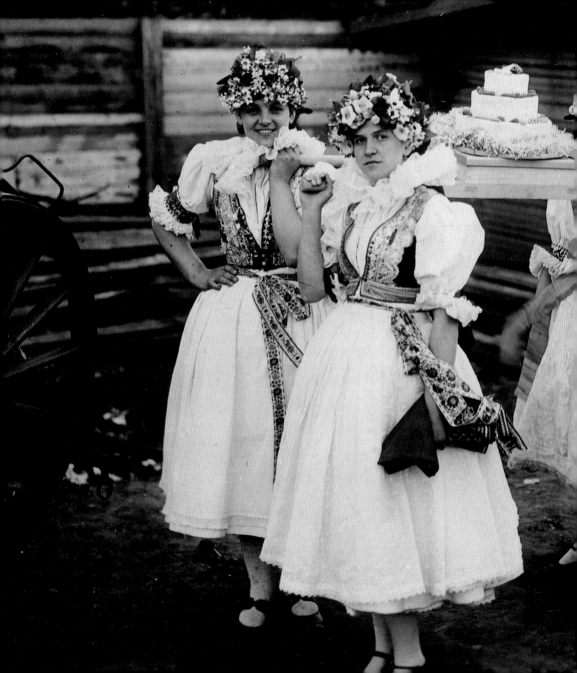

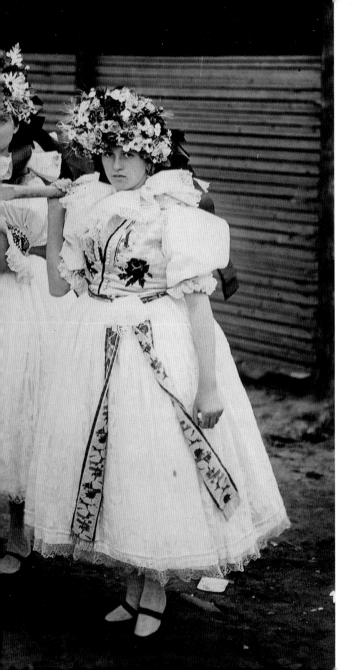

HULMA, MORAVIA,
CZECHOSLOVAKIA
1929
PUBLISHERS
PHOTO SERVICE

preceding pages
ROMANIA
2001
TOMASZ TOMASZEWSKI

TUTUILA ISLAND,
AMERICAN SAMOA
2000
RANDY OLSON

following pages
ATLANTA, GEORGIA
1988
JIM RICHARDSON

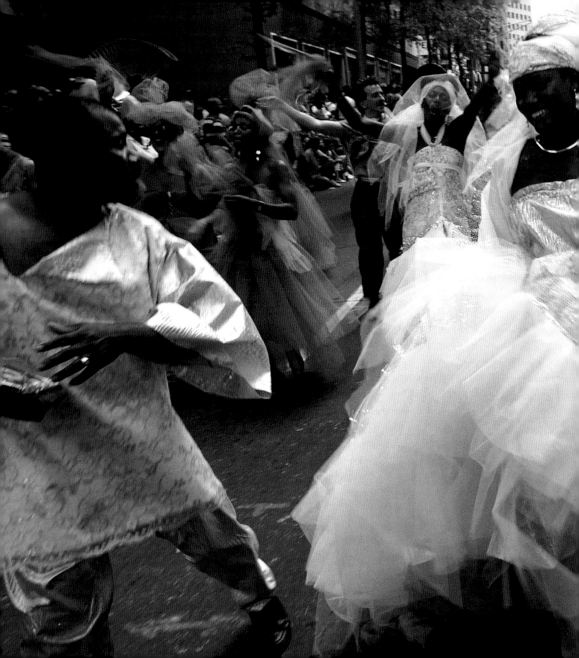

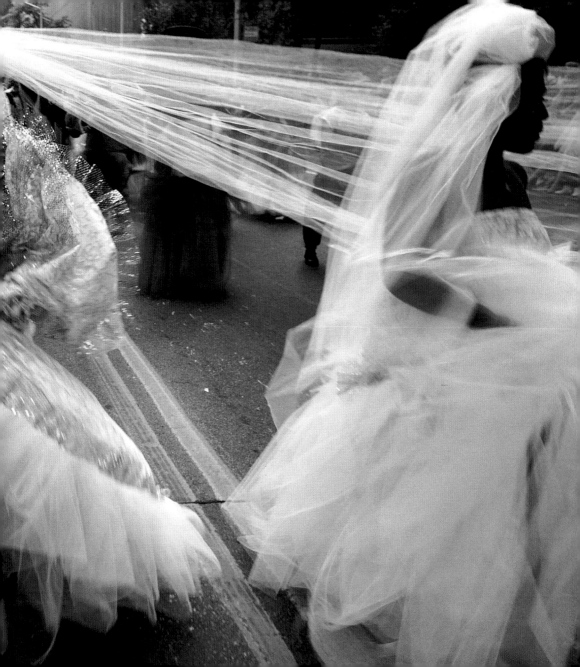

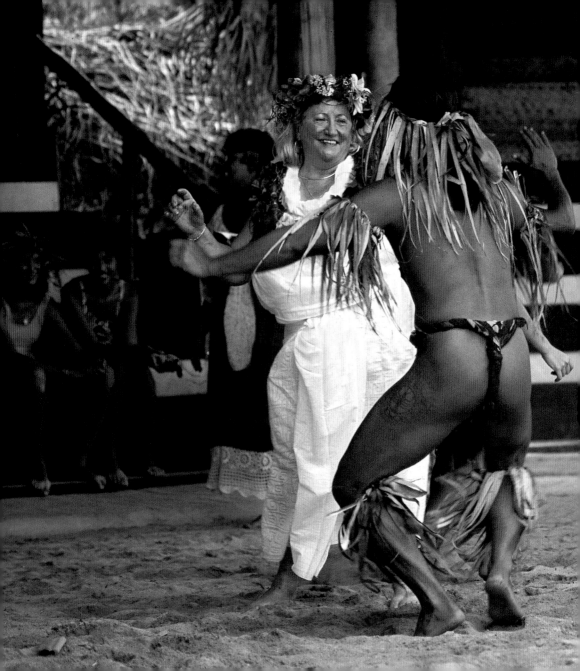

MOOREA,
FRENCH POLYNESIA
1997
JODI COBB

following pages
LENDAK, SLOVAKIA
1987
JOHN EASTCOTT
AND
YVA MOMATIUK

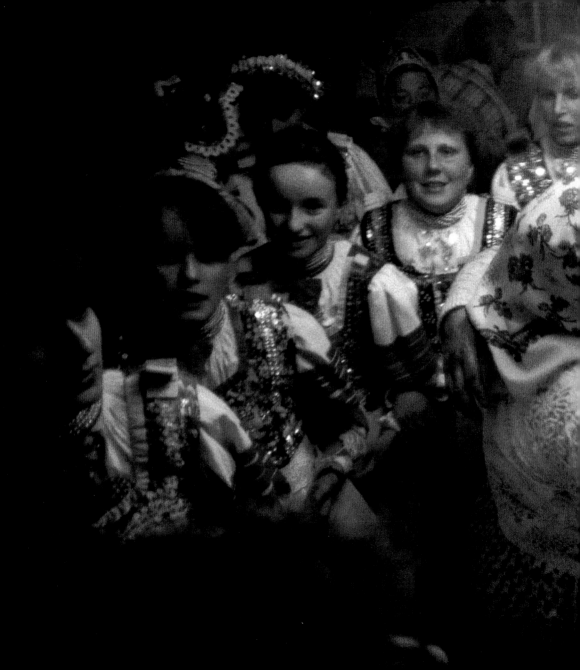

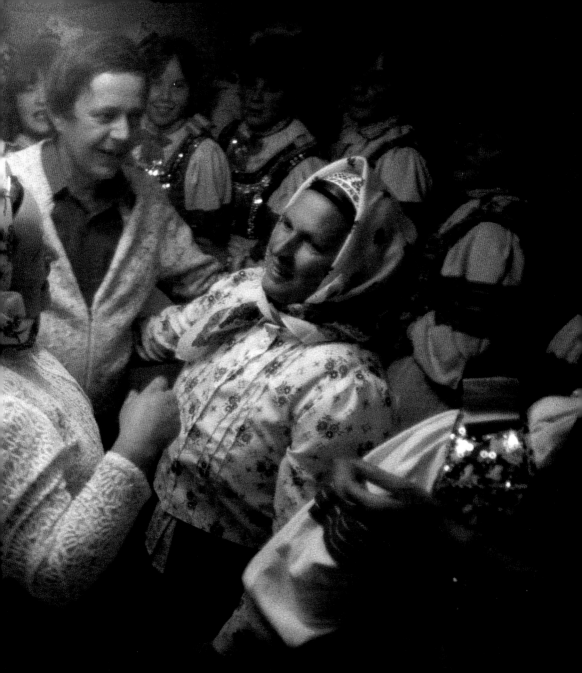

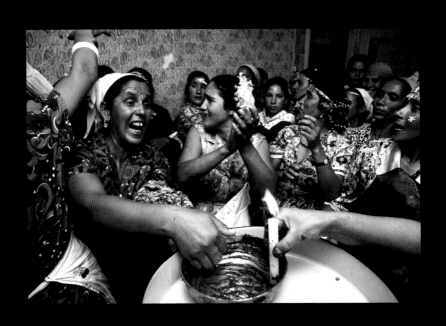

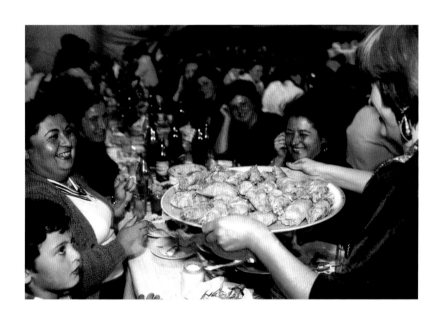

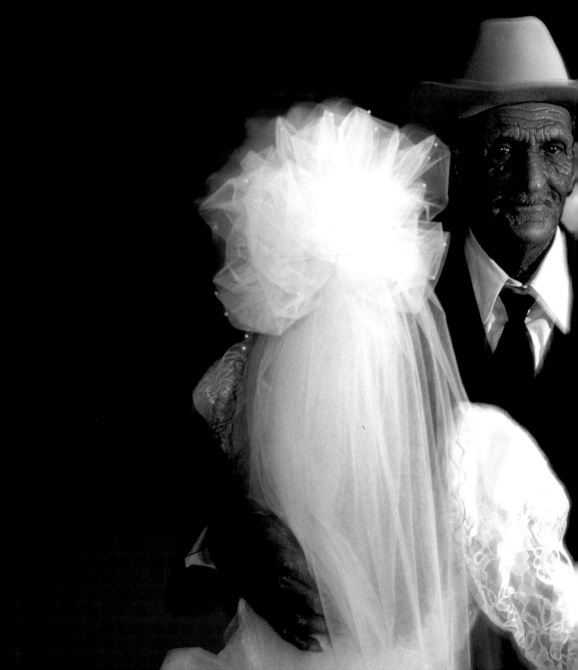

AUS

1990

MICH

prece

SKO

YUG

1970

BRU

MIRZ

1992

TOM

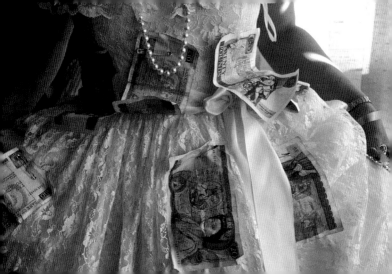

LONDON, ENGLAND
1990
JOE MCNALLY

MANILA,
THE PHILIPPINES
1990
SISSE BRIMBERG

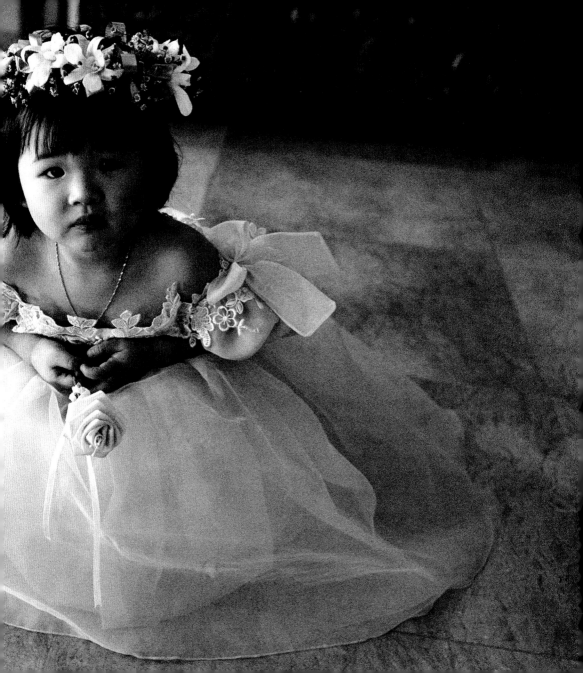

For their all-important wedding po

ait, sumptuously dressed couples select a choice location—the place they first met; their church, synagogue, or mosque; a cultural or geographical shrine; or their home-to-be. In traditional families—spread across Vietnam, Tunisia, the Sahara, Slovakia, India, and China—brides move into their husbands' houses. Their wedding photographs, stored away, hold memories for the couple, their children, and their children's children.

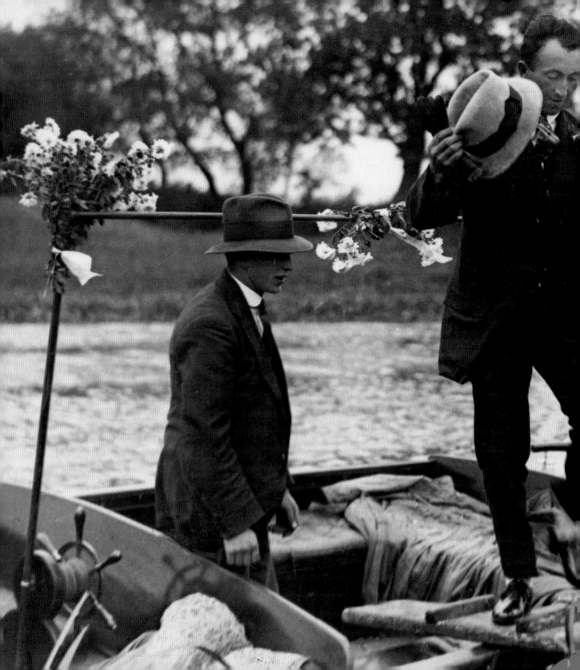

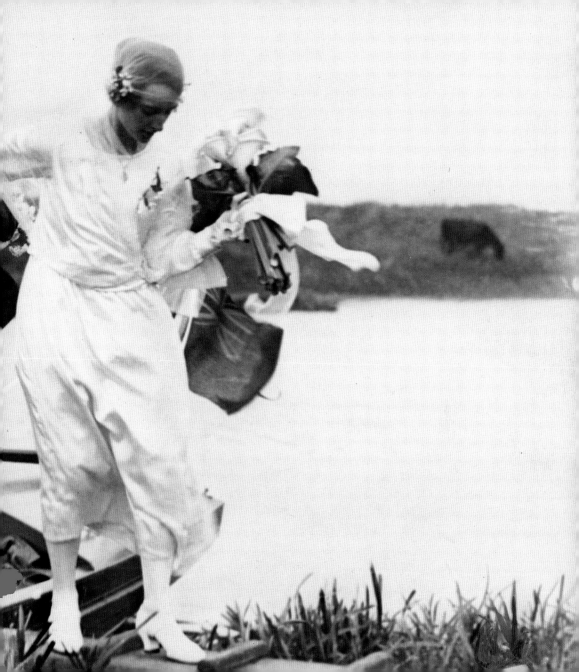

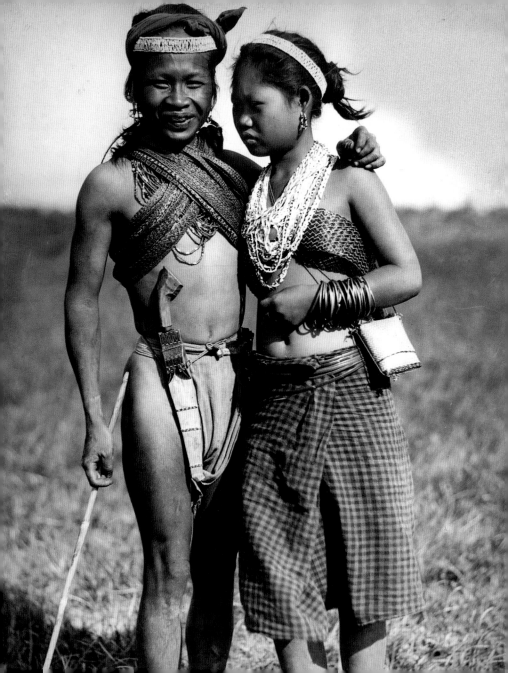

SAN JOSE, MINDORO,
THE PHILIPPINES
1930
G. W. GODDARD

preceding pages
PRICKWILLOW,
CAMBRIDGESHIRE,
GREAT BRITAIN
1929
STARR & RIGNALL

LAKE BAIKAL
1992
SARAH LEEN

following pages
INDIA
1917
BARTON & SON

SEOUL, KOREA
DATE UNKNOWN
UNDERWOOD &
UNDERWOOD

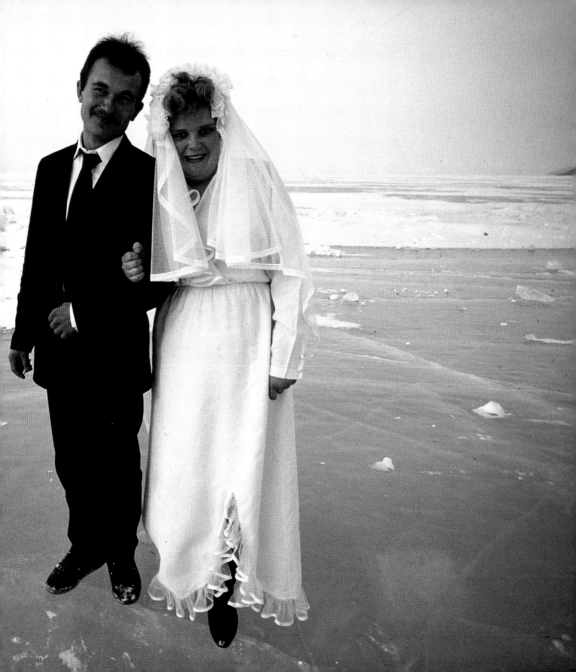

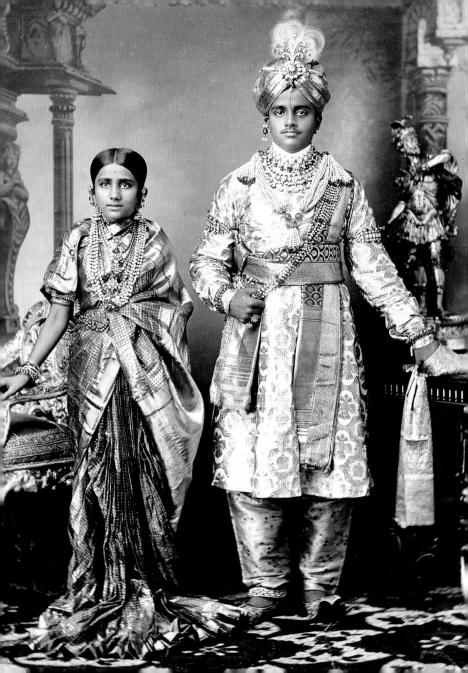

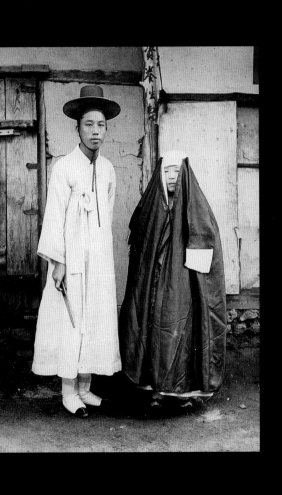

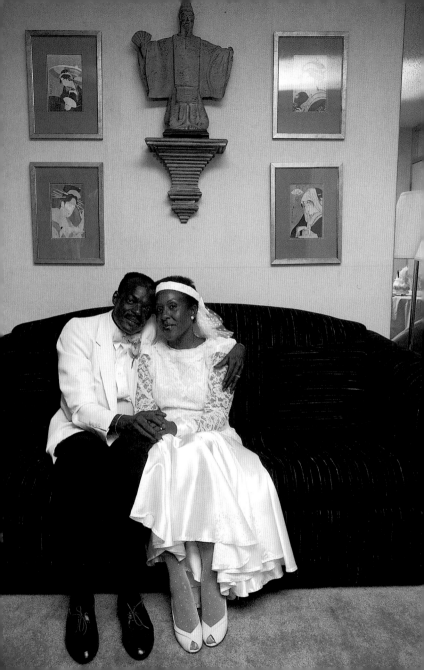

SHREVEPORT, LOUISIANA
1988
TOMASZ TOMASZEWSKI

EL PASO, TEXAS
1991
WILLIAM ALBERT ALLARD

following pages
LONDON, ENGLAND
2000
JODI COBB

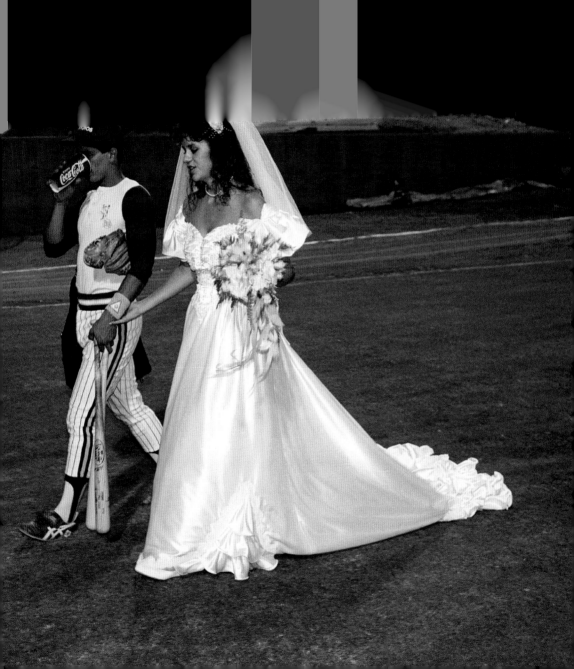

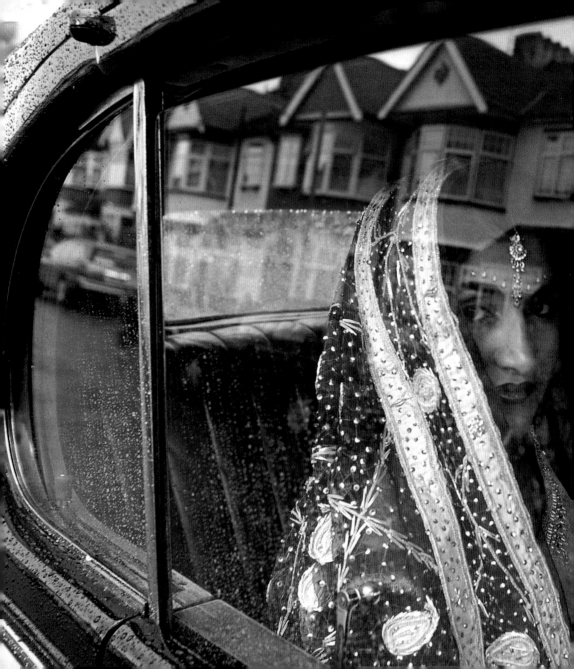

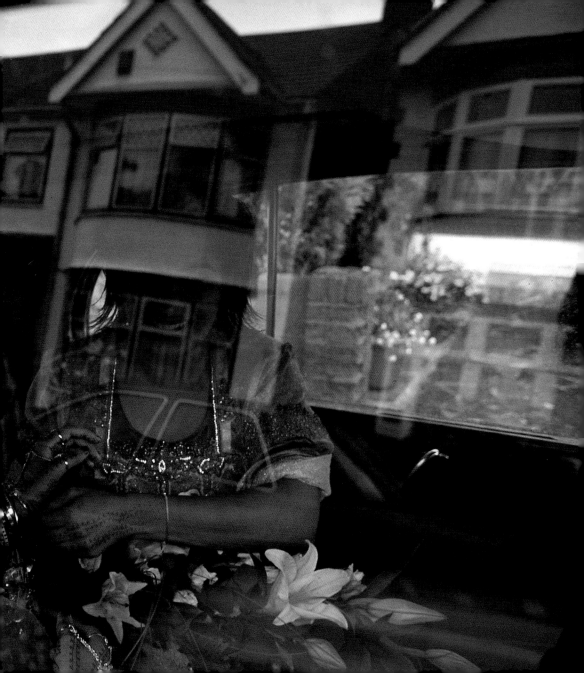

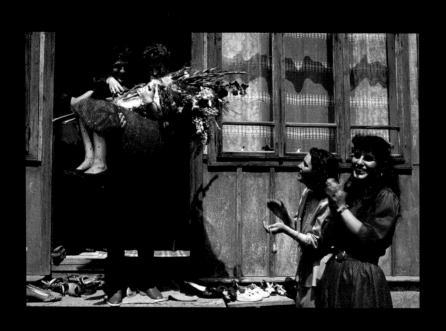

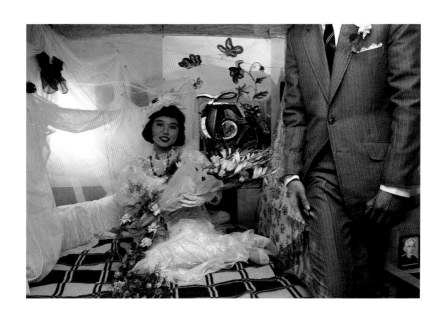

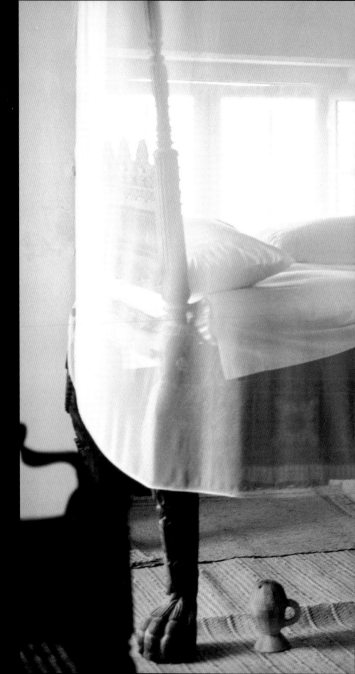

KENYA
1999
CAROL BECKWITH AND
ANGELA FISHER

preceding pages
MOLDAVIA, ROMANIA
1990
TOMASZ TOMASZEWSKI

HANOI, NORTH VIETNAM
1989
DAVID ALAN HARVEY

following pages
LINCOLN, NEBRASKA
2002
JOEL SARTORE

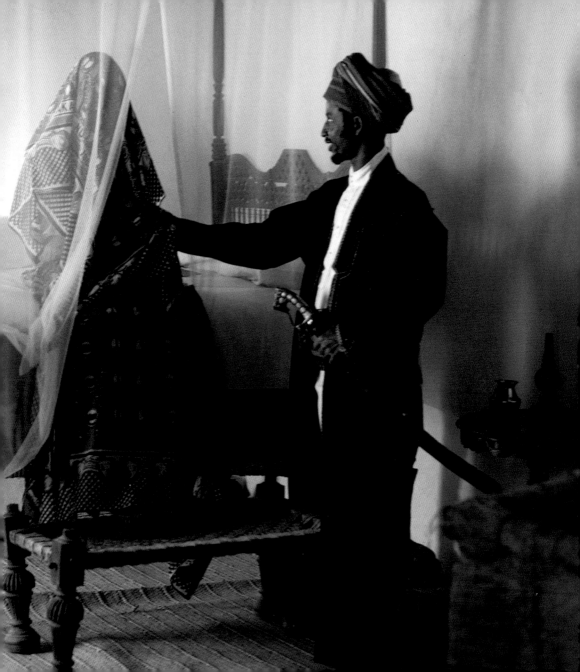

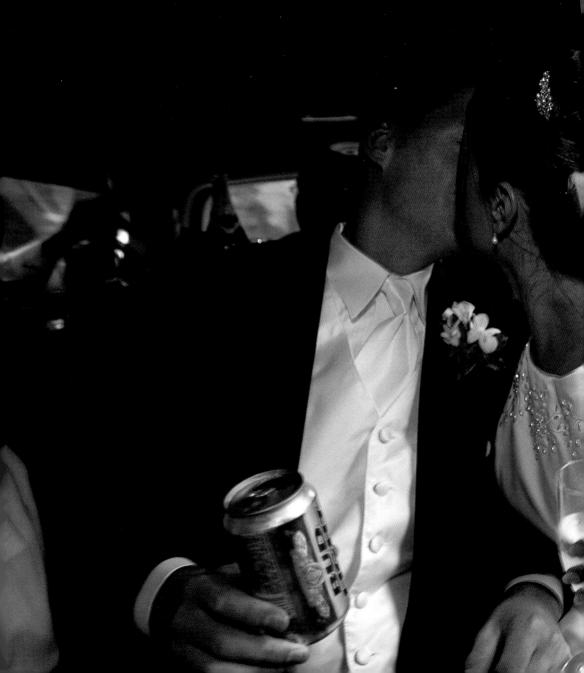

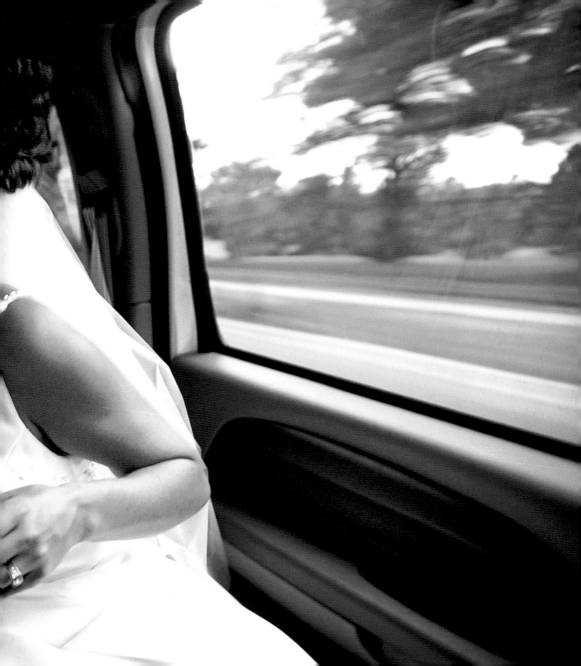

Weddings
by Leah Bendavid-Val

Published by the National Geographic Society

John M. Fahey, Jr., *President and Chief Executive Officer*
Gilbert M. Grosvenor, *Chairman of the Board*
Nina D. Hoffman, *Executive Vice President*

Prepared by the Book Division

Kevin Mulroy, *Vice President and Editor-in-Chief*
Marianne R. Koszorus*, Design Director*
Leah Bendavid-Val, *Editorial Director, Insight Books*

Staff for this Book

Leah Bendavid-Val, *Editor*
Rebecca Lescaze, *Text Editor*
Marianne R. Koszorus, *Art Director*
Vickie Donovan, *Illustrations Editor*
Joyce M. Caldwell, *Text Researcher*
R. Gary Colbert, *Production Director*
John T. Dunn, *Technical Director, Manufacturing*
Richard S. Wain, *Production Project Manager*
Sharon K. Berry, *Illustrations Assistant*
Natasha Scripture, *Editorial Assistant*

We would like to give special thanks to Susan E. Riggs,
Bill Bonner, and Patrick Sweigart for their hard work and
generous support for this project.

One of the world's largest nonprofit scientific and edu-
cational organizations, the National Geographic Society
was founded in 1888 "for the increase and diffusion of
geographic knowledge." Fulfilling this mission, the Soci-
ety educates and inspires millions every day through its
magazines, books, television programs, videos, maps
and atlases, research grants, the National Geographic
Bee, teacher workshops, and innovative classroom mate-
rials. The Society is supported through membership dues,
charitable gifts, and income from the sale of its educa-
tional products. This support is vital to National Geo-
graphic's mission to increase global understanding and
promote conservation of our planet through exploration,
research, and education.

For more information,
please call 1-800-NGS LINE (647-5463)

or write to the following address:

1145 17th Street N.W.Washington, D.C. 20036-4688
U.S.A.

Visit the Society's Web site
at www.nationalgeographic.com.

Front jacket and page 3: West Point, N.Y./1952/B. Anthony Stewart

Additional credits: p. 114-5, CORBIS; p. 139, CORBIS

nationalgeographicmomentsWEDDINGSnational
WEDDINGSnationalgeographicmomentsWEDDINGS
momentsWEDDINGSnationalgeographicmoments
graphicmomentsWEDDINGSnationalgeographic
nationalgeographicmomentsWEDDINGSnational
WEDDINGSnationalgeographicmomentsWEDDINGS
icmomentsWEDDINGSnationalgeographic
geographicmomentsWEDDINGSnational
WEDDINGSnationalgeographicmoments
icmomentsWEDDINGSnationalgeographic
lgeographicmomentsWEDDINGSnational
WEDDINGSnationalgeographicmoments
icmomentsWEDDINGSnationalgeographic
lgeographicmomentsWEDDINGSnational
WEDDINGSnationalgeographicmoments
icmomentsWEDDINGSnationalgeograp
lgeographicmomentsWEDDINGSnational
WEDDINGSnationalgeographicmoments